Creative
PHOTO
COLLAGE

Creative
PHOTO
COLLAGE

Marie Browning

STERLING

New York / London
www.sterlingpublishing.com

PROLIFIC IMPRESSIONS PRODUCTION STAFF:
Editor in Chief: Mickey Baskett
Copy Editor: Phyllis Mueller
Graphics: Karen Turpin
Styling: Lenos Key
Photography: Jerry Mucklow of Rocket Photography, Visions West Photography
Illustrations: Kaaren Poole
Administration: Jim Baskett

Every effort has been made to insure that the information presented is accurate. Since we have no control over physical conditions, individual skills, or chosen tools and products, the publisher disclaims any liability for injuries, losses, untoward results, ~~or any other~~ which ~~may result~~ from the use of the information in ~~this book~~. ~~The projects in this book~~ ~~paying particular~~ attention to all cautions and warni~~ngs shown for that product~~ ~~to ensure their~~ proper and safe use.

No part of this book m~~ay~~ be reproduced ~~for commercial purposes~~ in any form without permission by ~~the copyright holder~~. ~~The written~~ ~~instr~~uctions and design patterns in this b~~ook are intended for the personal use of the~~ reader and may be reproduced for th~~at purpose~~ only.

STERLING and the disti~~nctive Sterling logo are registered trademar~~ks of Sterling Publishing Co.,

Library of Congress Cataloging-in-Publication Data
Browning, Marie.
 Creative photo collage / Marie Browning.
 p. cm.
 Includes index.
 ISBN-13: 978-1-4027-3502-8
 1. Photocollage. 2. Photographs--Trimming, mounting, etc. 3. Photographs on cloth. 4. Scrapbooks--Design. 5. Handicraft. I. Title.

TT910.B758 2008
745.593--dc22

 2007052567

10 9 8 7 6 5 4 3 2 1

Published by Sterling Publishing Co., Inc.
387 Park Avenue South, New York, NY 10016
© 2008 by Prolific Impressions, Inc.
Distributed in Canada by Sterling Publishing
c/o Canadian Manda Group, 165 Dufferin Street
Toronto, Ontario, Canada M6K 3H6
Distributed in the United Kingdom by GMC Distribution Services
Castle Place, 166 High Street, Lewes, East Sussex, England BN7 1XU
Distributed in Australia by Capricorn Link (Australia) Pty. Ltd.
P.O. Box 704, Windsor, NSW 2756, Australia

Printed in China
All rights reserved

Sterling ISBN 978-1-4027-3502-8

For information about custom editions, special sales, premium and corporate purchases, please contact Sterling Special Sales Department at 800-805-5489 or specialsales@sterlingpublishing.com.

ACKNOWLEDGMENTS

I thank these manufacturers for their generous contributions of quality products and support in the creation of the projects in this book.

For glues for all surfaces: Beacon Adhesives, Mt. Vernon, NY, www.beaconcreates.com

For acrylic paints, acrylic mediums, acrylic varnishes, texture paint: Delta Technical Coatings, Whittier, CA, www.deltacrafts.com

For two part pour-on coating (Envirotex Lite): Environmental Technology, Inc., Fields Landing, CA, www.eti-usa.com

For decorative scissors, slide trimmer, art knives, cutting mats, Cloud 9 Design decorative papers, scrapbook embellishments, and stickers: Fiskars Brands, Inc., Madison, WI, www.fiskars.com

For decorative buttons, charms, and beads: Jesse James & Co., Allentown, PA, www.dressitup.com

For Royal Coat® and Mod Podge® decoupage medium, decorative Paint transfers for walls, FolkArt® acrylic paints, acrylic mediums, acrylic varnishes, and dimensional varnish: Plaid Enterprises, Inc., Norcross, GA, www.plaidonline.com

For Premo! Sculpey polymer clay: Polyform, Elk Grove Village, IL, www.sculpey.com

For paintbrushes and sponges, rub-on transfers: Royal Brush, Merrillville, IN, www.royalbrush.com

For dye pens for hand-tinting photographs: SpotPen, Las Cruces, NM

For wooden surfaces (shadow boxes, frames, plaques, clipboards): Walnut Hollow, Dodgeville, WI, www.walnuthollow.com

For adhesive and laminating systems: Xyron, Scottsdale, AZ, www.xyron.com

About the Author
MARIE BROWNING

Marie Browning is a consummate craft designer who has made a career of designing products, writing books and articles, and teaching and demonstrating. You may have been charmed by her creative acumen but not been aware of the woman behind it – she has designed stencils, stamps, transfers, and a variety of other award-winning product lines for art and craft supply companies. As well as writing numerous books on creative living, with over one million copies in print, Marie's articles and designs have appeared in numerous home decor and crafts magazines.

Marie Browning earned a Fine Arts Diploma from Camosun College, where she currently serves on a program advisory board in the Visual Arts department, and attended the University of Victoria. She is a design member of the Crafts and Hobby Association (CHA); as chair of the CHA Designer Trend Committee she researches and writes about upcoming trends in the arts and crafts industry. In 2004 Marie was selected by *Craftrends* trade publication as a "Top Influential Industry Designer."

She lives, gardens, and crafts on Vancouver Island in Canada. She and her husband Scott have three children: Katelyn, Lena, and Jonathan. Marie can be contacted at www.mariebrowning.com

BOOKS BY MARIE BROWNING PUBLISHED BY STERLING

New Concepts in Paper Quilling, (2008)
Creative Collage: Making Memories in Mixed Media (2007)
Paper Crafts Workshop: A Beginner's Guide to Techniques & Projects (2007)
Paper Crafts Workshop: Traditional Card Techniques (2007)
Metal Crafting Workshop (2006)
Casting for Crafters (2006)
Paper Mosaics in an Afternoon (2006)
Snazzy Jars (2006)
Jazzy Gift Baskets (2006)
Purse Pizzazz (2005)
Really Jazzy Jars (2005)
Totally Cool Polymer Clay for Kids (2005)
Totally Cool Soapmaking for Kids (2004 – re-printed in softcover)

Wonderful Wraps (2003 – re-printed in softcover)
Jazzy Jars (2003 – re-printed in softcover)
Designer Soapmaking (2003 – re-printed in German)
300 Recipes for Soap (2002 – re-printed in softcover and in French and Chinese)
Crafting with Vellum and Parchment (2001 – re-printed in softcover as *New Paper Crafts*)
Melt and Pour Soaps (2000 – re-printed in softcover)
Hand Decorating Paper (2000 – re-printed in soft-cover)
Memory Gifts (2000 – re-printed in soft-cover as *Family Photocrafts*)
Making Glorious Gifts from your Garden (1999 – re-printed in softcover)
Handcrafted Journals, Albums, Scrapbooks & More (1999 – re-printed in softcover)
Beautiful Handmade Natural Soaps (1998 – re-printed in softcover as *Natural Soapmaking*)

CONTENTS

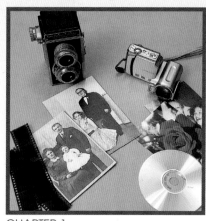

CHAPTER 1

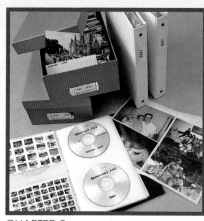

CHAPTER 2

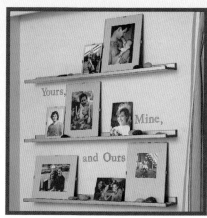

CHAPTER 4

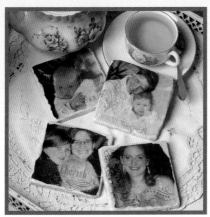

CHAPTER 6

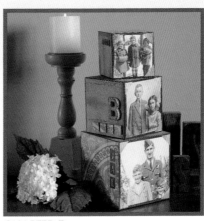

CHAPTER 7

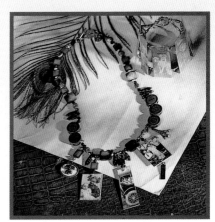

CHAPTER 8

Welcome to Photocrafting!

Making a collage involves assembling different forms to create a new whole. In this book, I share techniques that combine two of my favorite pursuits: crafting and photography. The resulting "photocrafting" techniques were used to create a variety of photo collage projects, all intended to inspire you to create memorable gifts and treasures using favorite photographs from both film and digital files. Although I am by no means a professional photographer, as a designer and artist I provide tips on taking better pictures, displaying your photo collections, and creating beautiful items to adorn your home and give as gifts.

The art form of photocrafting, which has emerged from the memory craft of scrapbooking, introduces new surfaces and takes scrapbooking to the next level. Photocrafting is more than just a hobby. It is a way of marking events and celebrations and preserves life's memorable moments. As our lives become more

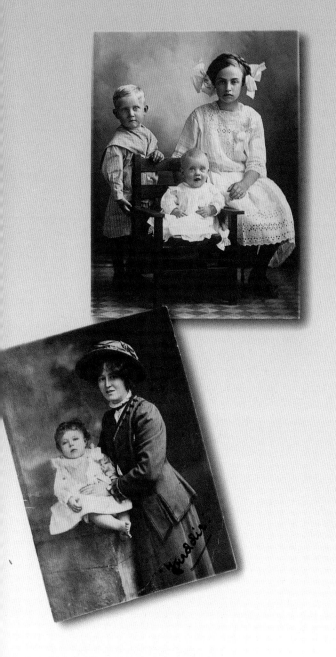

time-stressed and high-tech, the value of the effort and time that is put into memory projects deserves a special place.

Because we all have photographs and everyone loves to share them, the pages that follow include wonderful ideas for preserving memories and creating new ones to touch the past as your family crafts together. The projects are many and varied, with photos presented and displayed on coasters, trays, plates, boxes, canvases, shadow boxes, coat racks, and jewelry.

I am thankful that my ancestors felt it important to preserve their life stories in photographs. Their legacy inspires me to create treasures and traditions my children can embrace. Arm yourself with enthusiasm, give yourself permission to be creative, and make a special family memento that recalls a special event or a loved one and celebrates your history.

Marie Browning

ABOUT PHOTOS

With the rapid advancement of technology, photographs and photographic techniques are more accessible today than ever before. Cameras are easier to use and less expensive, and they allow you to achieve nearly professional results. With digital cameras, you can process, manipulate, and print your own photos. There are also a great number of artistic effects that can change your photograph into a watercolor, oil painting, an impressionist portrait, or even an Andy Warhol-style poster. Don't be afraid to experiment!

A Very Brief History of Photography

The word photography comes from the Greek word *photo,* meaning "light" and the word *graphein,* which means "to draw." The word describes exactly what photography is – drawing with light.

It is not a modern invention. Aristotle made a reference to the *camera obscura* in 330 B.C.E. The camera obscura (*camera* is the Latin word for room, *obscura* in Latin means dark) is a darkened chamber in which an image of an object is received through a small opening and focused on a surface. The projected image, made with a pinhole in a very dark room on a sunny day, was in full color with movement, but the image was upside down. In 1490, Leonardo da Vinci gave clear descriptions of camera obscura in his notebooks as a device for artists learning to draw. The convex lens, added in the 16th century, greatly improved the quality of the projection. In 1727, when Professor J. Schulze mixed chalk, nitric acid, and silver and accidentally created the first photosensitive compound, it became possible to capture the projected image permanently.

By the time of the American Civil War in the 1860s, photos were made using large glass negatives. Around the same time, color photography was invented by using three cameras with color filters and combining them to create one photograph. Photography was still a mystery to the average person, the purview of highly trained professionals, until February 1900, when a new camera appeared that was inexpensive and easy for everyone to use, even children. This innovation by Kodak launched a new industry and forever changed how we communicate by allowing individuals to document everyday events and family histories. The camera itself remained basically the same – a light-tight box with a lens – until 1975, when Kodak developed the first working digital camera. By 1990, the first digital cameras were available to consumers and computer technology made photo editing available to even novice photographers.

Digital vs. Film

While this topic is a subject of passionate debate among professional photographers, I believe the answer is an easy one for amateurs – digital is definitely the way to take pictures. (Whether or not a professional can achieve better results with film is unresolved.)

Throughout the history of photography, convenience has always won over quality. For example, early photos taken in 1860 with wet glass plates have excellent film quality (and are far better than photos taken with the average digital camera), but they are hardly convenient. All early photographers were professionals; today most people taking pictures are amateurs. We have the ability to capture images with small digital cameras, even our cell phones, instantly but with a decline of picture quality.

However, whether you use a film or digital camera, you're using a tool to create the same thing – a photograph. And because digital photography is still relatively new, and many of us have both film and digital photographs, all the projects in this book can be created with photos from either format, allowing you to choose from your entire collection of images.

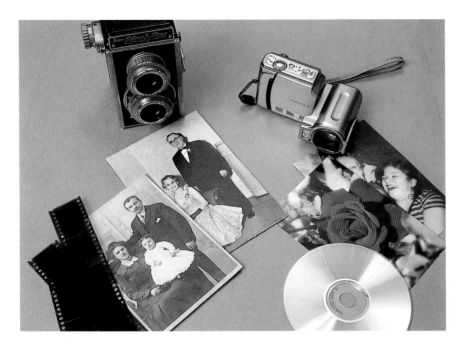

Pictured here is the old technology vs. the new technology. At left is a film camera, vintage photographs and film negatives. At right is a digital camera, printed photographs, and a CD used to store the photo files.

Advantages of digital photography

- Digital cameras are very convenient and easy to use.
- You get instant, immediate feedback that allows you to correct common mistakes. Film photography requires more experience to produce a good photo, and things can go wrong with the picture that cannot be corrected right away.
- The quality of digital is fine for most photographs and is comparable to 35mm film when printed up to 8" x 10". To beat the quality of a digital photograph, you need to be a proficient film photographer.
- Digital photos are easy and fun to send by e-mail, and can be sent immediately.
- Hard drives can store many images in a little space; film negatives and prints can take up many binders and boxes.
- Digital photos are easy to organize and locate on your computer.
- With a digital camera, you can shoot as many pictures as you want at no cost. With film, you have the expense of film and processing costs before you ever see the results.
- Advances in computer technology have made photo editing easy for even novice photographers, enabling creative experimentation with special effects.

Advantages of film photography

- In film, what you see is what you get. Digital photography has raised ethical concerns; for example, many courts of law will not accept digital images because they can be manipulated so easily.
- Film has a broader range of colors.
- Film cameras can allow for more creativity while shooting. The possibility of long exposures and double exposures are more difficult with most digital cameras.
- Image quality of film is better. A print made using a glass plate negative from the late 1800s has better resolution than most digital photographs. You would need a 25-megapixel digital camera to equal the resolution of 35mm film.
- Film photography has 100 years of history and refinement, while digital photography is brand new.
- Film is more permanent and does not erase itself!
- A film camera that's 50 years old is still functional, while a digital camera can become obsolete in a year or two.
- The process has stayed the same for decades. Will computers 20 years from now be able to read today's .jpg?
- Digital cameras cost four times more than most film cameras.
- Film will not go away, much like movies did not go away with the invention of the video camera.

What's in Your Viewfinder?

Tips for Taking Great Photographs

Photography is the art of observation and finding interesting images in ordinary places. The camera is a tool that you, the artist, controls. Following these few basic tips can help you dramatically improve your photography skills.

• Don't always pose your subjects; capturing people unaware makes great photos. Be attuned to your surroundings and watch for special moments that just shout to be recorded.

• Be sure your camera battery is charged or that you have extra batteries with you. You don't want to miss the perfect shot because the battery is low.

• Don't be afraid to get close to your subject or use your zoom feature. Many photographs have too much empty space around the focal point.

• Choose a focal point. For example, take a close shot of a single flower, rather than a patch of flowers.

• Create dynamic and interesting photos with different views. Rather than taking a photograph straight on, consider standing on a chair and looking at your subject from above or crouching to take a vertical photo. When photographing pets and children, get on their level for a more intimate shot.

• Choose the best way to capture your subject(s). Don't always place the subject in the center of the photo – create visual appeal by placing the subject off-center. When you do, you can include more of the surrounding elements. And don't center the faces of your subjects in the photo – many times, this leads to cut-off feet and way too much sky in the picture.

• To avoid blurry, out-of-focus shots, use a tripod. I love the small chest tripods that also work as a camera grip. If you do not have a tripod, steady yourself against a stable object such as a desk or tree. Take a deep breath and hold it while you gently press the button to take the picture.

• For planned group photos, have everyone dress in coordinating clothes. White shirts and blue jeans are a classic choice. Or try solid color clothes without patterns, logos, or printing on shirts. To guarantee a good group photo, take plenty of shots.

• Watch the light. When shooting outside, place the subjects in the shade with their backs to the sun. If needed, use a flash to lighten their faces. Photos taken on overcast days provide perfect diffused light rather than the harsh shadows of a sunny day. When taking photos inside in the daytime, take advantage of available natural light by placing the subjects near a window.

• Pay attention to everything that's in your viewfinder and clear away clutter in the background. Sometimes shifting your position will greatly improve the photo. When photographing flowers in my garden, I often place a white foam core board behind the subject to remove the background. A photo with a white background is easier to manipulate with special effects in a photo-editing program.

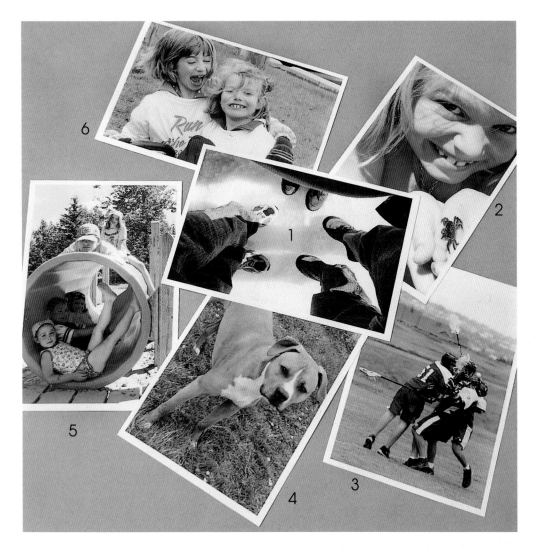

1 – A different angle
(people standing on
a glacier)
2 – Extreme closeup
(Laura and a crab)
3 – Action photo
(sports event)
4 – Closeup at an angle
(pet photo)
5 – Posed (children at a
park)
6 – Spontaneous
snapshot
(kids at play)

• Watch for plants or poles behind your subjects. If you aren't careful, it will look like something is growing from your subject's head. Ask the subject to move slightly or try a different angle.

• When photographing people at special events, include some close-ups of elements that add to the story, such as hands, eyes, or accessories.

• The more photos you take, the better chance you'll have of capturing one (or more) you love. With digital cameras, simply delete the ones you don't like.

• Create your own style and have fun. Like any hobby, photography takes practice. The more pictures you take, the better a photographer you will become.

STORING & PRESERVING
PHOTOS

Getting your photographs and memorabilia organized so you can start creating may be the hardest task of all! I found the easiest way to organize my collections was to use large photo boxes and file cards to sort and document my photographs and other memorabilia. As I rarely use an actual photographic print on a project, I make sure the picture I want is easy to find as well as easy to file. Treasures such as shells from a beach holiday, a ticket stub from an evening at the theater, pressed flowers from your graduation, or a ribbon from the school's sports day all deserve a special place.

Who's That?

Having trouble identifying people in your photographs? When was it taken? At what event? If photographs are not labeled, whether it was 1903, 1973, or 2003, details could be lost forever. Starting today, label each photo with all the pertinent information! Documenting all your photographs can be a huge task, but it's extremely rewarding to have helped preserve your family's history. Here are some hints for identifying older, unlabeled photographs in your collection:

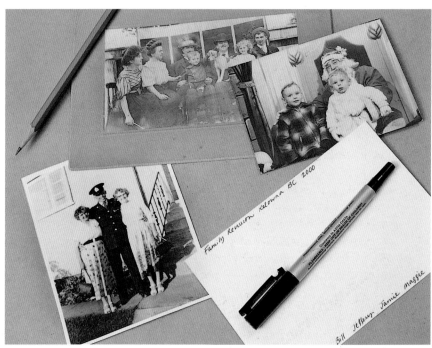

Who's that? Use safe markers or a labeling system to identify people in group photos.

• Ask the family! Schedule an event where you can get together with family elders and label all those mysterious photos. It will be fun remembering moments in your family's history, and it will make a huge task more manageable.

• I find studying clothing and accessories to be the best way to (approximately) date a photo. After you have identified a time frame for the photograph,

you can narrow the possible subjects by consulting the family tree.

• The type of photograph also helps identify the time. Go to web sites that talk about the history of photography for help in identifying the approximate date a photograph was taken.

Labeling Your Photos

Make sure you clearly date and document each photograph when preparing your files – the dates, names, and occasions will be invaluable when you add journaling and documentation to a project. A soft lead pencil is recommended for writing information on the backs of photographs. Pencil lead is harmless to photographs and, unlike some inks, won't stain or run if the photo gets damp. However, a pencil will not write on modern coated photographic paper. For these photos, use a permanent black marker to identify and document the event. Here are some helpful tips for labeling:

• Do not use a hard lead pencil on the back of older prints – it will leave an indentation. Instead, choose a 2B pencil. Always write on a hard, clean surface with light pressure.

• Use a fine-tip permanent marker (the type with a needle tip is excellent) for labeling photos printed on newer coated papers. When using a marker, make sure the ink is completely dry before stacking the photos.

• Do not use a ballpoint pen or non-permanent felt marker – they smudge and could bleed through to the front of the photograph.

• Label a photo on the back along an edge; that way, if the ink damages the photo or if the photo is accidentally embossed by the writing implement, the damage will be restricted to the edge, not the main part of the image.

Preserving Photos

We've all heard about using "acid-free" materials to preserve photographs for future generations, but the more appropriate terminology is "pH balanced," as all materials have a trace of acid, and it is the balance that makes them safe. By all means, use "acid-free" materials whenever possible for your photocrafting projects, but be more concerned about preserving the original photographs.

Color photographs of John F. Kennedy from the 1960s that were carefully stored in sterile museum quality environments are fading away because of the unstable qualities of older color photograph. The quality of the color print has greatly improved over the last 30 years, but it is still wise to put a roll of black and white film in your camera each year and take some pictures to ensure that some of your photographs will stand the test of time. (Black and white prints from the mid-19th century are holding up beautifully.)

Displaying Photos

Properly framed and matted photographs should not be displayed in direct sunlight or under bright spotlights. Damp places like kitchens and bathrooms can also quickly damage a photo. Most home lighting will not cause damage, but it can slowly fade a photo and the effects may not be noticed until years later when the irreversible damage is done. Treasured photos you wish to pass down for generations should not be displayed. Make a duplicate copy (or have one made) to display and keep the original safely stored.

Storing Photos

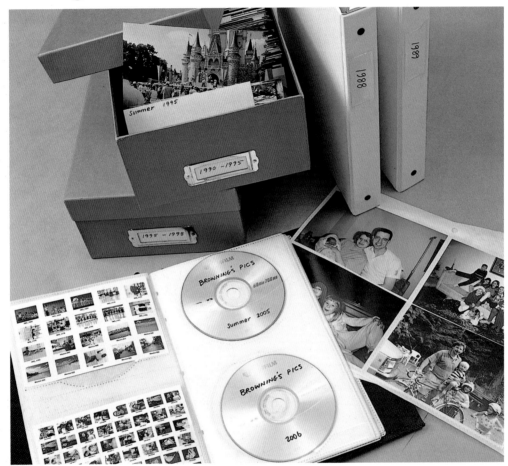

Pictured: Photo file boxes with file dividers, binders, binder sleeves, CD folder with picture index cards.

Storing Film Photographs

Photographs should be stored in the coolest, driest place in your home that has a consistent temperature year round. Basements are cool, but sometimes too damp. Damp locations cause the photos to stick together and promote mold growth. An above-ground interior closet that maintains a constant temperature is the ideal location for storing your photographs.

Purchase storage boxes and plastic binder sleeves from a photography store, and choose storage products made from materials that pass the American National Standards Institute (ANSI) Photographic Activity Test. Look for paper enclosures, envelopes, and file dividers made of high quality, non-acidic, lignin-free paper made from cotton or highly purified wood pulps. (I purchase 8½" x 11" archival

quality papers from a local scrapbook store and cut them into 4¼" x 5½" file dividers. This size is slightly larger than the most common size photo (4" x 6") in my collection. I use a permanent marker to write on the tops of the cards to separate the photos by year or specific event, and I store the photographs vertically on their long edges in storage boxes, separated with the file dividers. TIP: Do not over-stuff or under-fill the boxes; this can cause damage when photos are pulled out or filed away.

Photography stores also carry binder sleeves for the standard print sizes up to 8" x 10". You can store photographs in the plastic sleeves and group them in binders marked with the year. Store the binders upright in a box or on a shelf in your storage closet.

Storing Digital Photos

A digital camera enables you to take practically limitless numbers of photographs, and you will soon find yourself needing a system to manage them all. Many digital cameras come bundled with a photo management tool so you can organize files by date, subject, location, or other criteria. Here are some helpful hints for saving and storing your digital files:

- Organize the photos into a system you can understand. Give them names that will make sense a year from now. I tend to label photos by event and year ("Summer Holiday 2006" or "Katelyn's Birthday 2007").

- Set up a regular schedule for saving your digital photos to a CD or, better yet, every time you download pictures from your camera, copy them onto a CD. Always test to make sure the photos were transferred to the CD successfully without write errors before deleting them from your hard drive. This procedure helps to clear clutter from your hard drive and ensures you won't lose your photographs if your system crashes. I learned this the hard way – a bolt of lightning hit a power pole near our home and destroyed the inside of my computer and all the files, including two years of unsaved photographs. Many people lose files because they don't back up properly.

- Since CDs are inexpensive, why not make two copies and store one at a separate location as a backup? If there is a fire or flood you'll have a replacement. Possible separate locations could be a family member's home or your office.

- Store the CDs in a folder and accompany each file with a picture index for easy reference. Many photo management programs come with the option of printing a picture index. You can also print a verbal index describing the photos that are on the CD. Make sure the index is labeled the same way as the CD in case they get separated.

- When you're ready to edit a photograph, it's good practice to make a copy of the file first and then manipulate the copy.

Journaling

Journaling is equally important in scrapbooking and photocrafting. Proper documentation and labeling provide decorative elements and add significance and meaning to a project. Gold and silver paint pens, permanent markers, stenciled letters, and rubber stamp alphabets can all be used to add personal touches and significant sayings to your projects. I also find books of phrases and expressions useful.

I have downloaded many type fonts for my computer – I have to admit I am a font junkie. I often use computer-generated type as journaling for my projects. Fonts can be free, or cost hundreds of dollars. I have had wonderful success with a site that only charges 99 cents per font with no problems of downloading. Fonts are fun to use, and having a large selection makes your projects extra special.

Some Tips on Using Fonts

- Make sure your decorative fonts are readable.
- When using a decorative script alphabet, do not use all capital letters in a word.
- Don't let the font upstage the photograph. Use them to accent the photo's focal point.

Using your own handwriting as journaling is always a good addition to vintage photocrafts. When hand lettering, write neatly and use lightly penciled lines to keep the writing even. For a whimsical look, write in swirls, waves, or curls. Metallic gel pens can turn ordinary handwriting into a beautiful accent.

Learning to write a simple italic alphabet with a chisel point felt marker adds elegance to your projects. When using felt markers, make sure the point of the marker is not too thin or thick. TIP: Plan the lettering before writing on a project. One way to do this is to write the words on a piece of vellum and move it around to determine the best placement and size.

REPRODUCING PHOTOS
FOR PHOTOCRAFTING

If you are using film photographs, it is a good idea to make a photocopy for crafting and keep the original photographs and negatives stored and labeled. If you are using digital photos, you can easily print what you need.

Printing Your Own Photos

Printing photos was once a job for the photo lab, but with home computers and printers we can print as many photos as we wish, when we wish, as we need them. If you have taken your photos with a digital camera, the appropriate software will enable you to make prints easily. If you have a print of a film photograph, you can scan the photo on a flatbed scanner linked to your computer (many printers also have a scanner function and come with scanning software) and print the photo. You can store the scanned image in your computer and preserve the original.

Printers

Home printers make it easy to quickly print photographs. For best results, use the paper recommended by the printer manufacturer. I have occasionally succumbed to buying cheaper papers – with disappointing results. Although I prefer an inkjet printer, sometimes an inkjet photo print is not suitable for a project because the paper may be too thick or because the water-soluble ink would run. In these cases, I take the inkjet print to be color photocopied.

Papers

In addition to very white, professional-looking glossy or matte photograph paper, a wide range of specialty papers is available for printing photographs. Vellum, transparency film sheets, fabric transfer paper, card stock, various types of handmade papers, wood veneer sheets, cork sheets, or specialized surfaces designed for an inkjet printer can be used. **Be cautious!** Print at your own risk when you use papers or surfaces not specifically designed for your type of printer, such as cork or wood veneer. I have experimented with many different surfaces and have not yet ruined my printer, but do realize experimenting could harm your printer.

Translucent plain, pearl finish, or colored **vellum papers** sometimes work better with a laser printer than an inkjet printer as inks may blur and run on some vellums. However, this can be a nice effect – the photograph will look like a watercolor painting. Sometimes the ink does not run – it depends on the type of vellum. For best results, make a practice print. When printing on vellum, print one sheet at a time and let dry before stacking, as the ink takes a little longer to dry.

You can purchase **clear transparent sheets** specifically for inkjet printing. They are coated and readily take ink. If you don't use the proper transparent sheet for inkjet printing, the ink will bead on the surface and not dry.

There are a great many **fabric sheets** available to use in your printer, from heavy textured canvas to sheer organza, that have a peel-off paper backing. Fabrics printed with an inkjet printer usually are not washable and can be used for decorative purposes only. To create a printed, washable fabric, print on an iron-on transfer sheet.

Effects of Printing on Different Surfaces
1 – *Professional gloss paper* 3 – *Canvas fabric* 5 – *Vellum*
2 – *Clear transparent sheet* 4 – *Sheer organza fabric* 6 – *Pearl finish vellum*

You can make printable fabric sheets for your printer by ironing the fabric to the shiny side of freezer paper and then cutting to size (8½" x 11") with a rotary cutter, ruler, and cutting mat. After printing, simply peel off the freezer paper. I have had great success using sheer and smooth cotton fabrics, but use caution – with this homemade version of a printable fabric surface, you do it at your own risk.

Photocopying Photos

Many of the projects in this book are created from photocopied images. Sometimes it's best to use a color photocopy of a photo print, particularly if you are using prints of film photos. Using photocopies gives you a little more flexibility and ensures that if you do make a mistake, the original is safe.

Papers

Several different types of papers are available for use in color photocopiers. It's a good idea to **always** ask the advice of the photocopy operator regarding compatibility of specialty papers and their machines. Here are some options to try:

- **Transfer paper** is used to bond images to fabric with a household iron; transfer paper can also be used to transfer pictures to polymer clay. Find it at color photocopy shops or crafts and fabric stores.
- **Clear sheets** (transparency film sheets) are commonly used in businesses and schools to project images with overhead projectors. Photographs printed on them make wonderful images when working with light, such as in window pictures, night lights, and candle lanterns.
- **Parchment and vellum** can be used in copiers with attractive results. Vellum comes in several colors as well as imbedded with sparkles and glitter for a beautiful, festive image. **Note:** Many photocopy centers will not put vellum through their larger machines because of the copier's high heat and the risk of damaging the copier. It is usually best to use a smaller color copier – which is not as hot – to prevent this.
- **High gloss paper** can simulate actual photographic paper when you wish a more realistic photo reproduction on a thinner sheet.

Learn About Copiers

Get to know the people at the photocopy shop and learn about what their machines can do. This builds up trust – when you have an unusual request, they will be more obliging in experimenting with their very expensive machine.

While creating the projects for this book I asked the clerks at my local photocopy shop to experiment with all types of paper and techniques. They allowed me to take home the machines' operating manuals so I could learn about different special effects and what the machines could and could not do. This also helped the operators learn more about their machines and do far more for their customers than just plain color photocopies. Fortunately, most of my experiments did work, and no damage was done to the machines.

Gang Up Sheets

Color photocopies can be expensive; "ganging up" your photographs can save money. Place as many photographs as you can on a standard or legal sized piece of paper and photocopy them as one. Use a small piece of double-sided tape to adhere the photographs to the paper and remove the tape immediately after the copies have been made. For better copies, separate black and white photographs from color photographs when ganging up your images.

Ganging up photos for color copying.

Black & White Photographs

When photocopying black and white photographs, reproduce them on a color photocopier. This ensures a clear copy with all the gray-toned shadows and white highlights. A black-and-white (regular) copier will only reproduce blacks and whites and result in an inferior image. When photocopying an old black and white photograph, a color photocopier will reproduce the beautiful sepia tones the photograph has developed over the years.

Original black and white photos.

This shows the photo copied on a color photocopier.

This shows the photo copied on a regular copier.

This shows the photo copied on a color photocopier in the black and white mode.

21

Photocopying Photos, continued from previous page

Enlarging & Reducing

All color photocopiers have the ability to enlarge or reduce your images. This feature is important when you are designing your project. You will want to reduce photographs for jewelry pieces and enlarge photographs for projects such as trays or home decor pieces. When you are ready to photocopy the images, tell the copier operator the exact size you want. Measure your project carefully so you only will need to make one copy. A proportion wheel or a slide rule is handy so that you can figure the % of enlargement or reduction without having to do calculations.

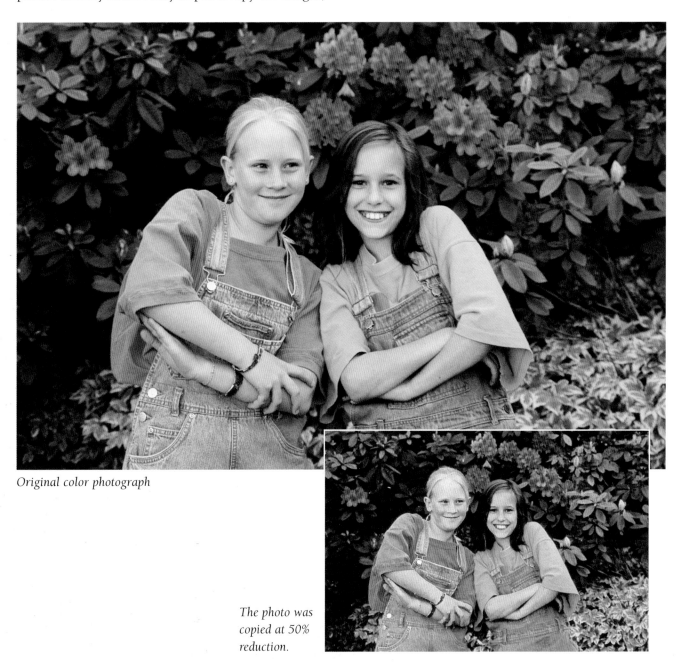

Original color photograph

The photo was copied at 50% reduction.

Reverse Imaging

You will need this feature when photocopying on transfer paper to iron on fabric or press on polymer clay. It's particularly important if there is lettering in the picture.

Repeat Images

Many color photocopiers can make multiple prints on a single sheet of paper. Ask your operator if the machine can do this. It's useful for photo card making, practicing color tinting, and creating three-dimensional photos.

Original photo

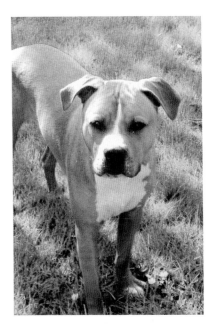

Photocopied in reverse

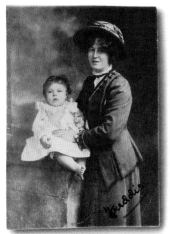

Original photograph

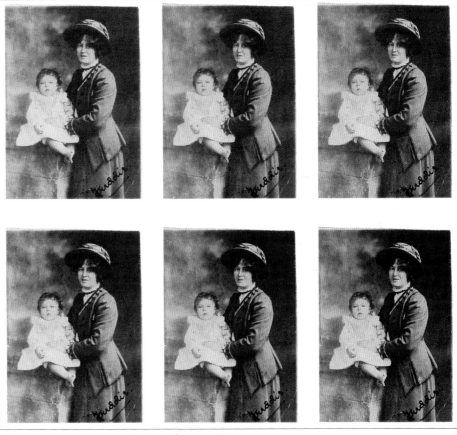

This shows a photo copied sheet of repeated images.

Photocopying Photos, continued from previous page

Monotone Images

Many color photocopiers have the ability to copy your image in single color tones, which can provide creative opportunities for your projects. I like to use this technique to make warm sepia-toned images (similar to the patina of old photographs) from color photographs. You can also change color photographs into black and white and use color tinting techniques.

The examples on these two pages show the different intensities of color with monotoned copies. The sepia copy has good contrast while the pink copy looks washed out. The copier operator can vary the contrast so that you can create a soft, low contrast copy or strong, contrasted copies, depending on your project and the look you want the photo to achieve.

Original photo

Sepia monotone

Blue monotone

Pink monotone

Computer Special Effects

Using basic photo manipulation techniques, it's easy to make an ordinary photograph great. You don't need to invest a great deal in editing software – many simple fixes and special effects come bundled with your camera or can be easily found online for free at photo management sites. (One of my favorites is Picassa, a free software download from Google, because it's so easy for beginners to use.) The special effects I used on the photographs for this book's projects are simple enough for beginners. Remember to **always** save a copy of your original photograph before editing it.

Cropping

Cropping is the easiest and best way to improve a photograph. It removes unwanted clutter and helps to highlight the main subject. Cropping later is easier than trying to worry about creating the composition in the camera's viewfinder.

Pictured below, the first photo is the original frame of the photo taken. The second photo shows how cropping can improve a photo.

Black & White

With a click you can quickly remove the color from a digital image. Without color, shapes and the photo's composition become more apparent. It's a good way to take away a busy background or improve red faces.

Pictured below, the first photo is the original color image. The second photo shows how the photo was cropped, as well as how it looks in black and white. Soft focus was also added to the photo.

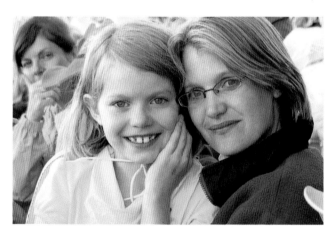

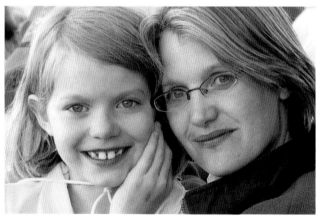

Cropped photo

Reproduced in black and white

Computer Special Effects, continued from previous page

Sepia Tones

Using soft, warm sepia tones gives a photo a vintage look. I also like to increase the grain of the photograph when changing to sepia tones.

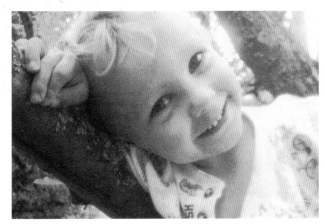

Spot Coloring

This is a quick way to focus on an element and to give the photo a look of hand tinting.

Soft Focus

You can create a mood, blur unwanted elements in the photograph, or highlight an element by using the soft focus effect. Programs allow you to manipulate the intensity and the size.

Photo Collage

Interesting changes can be achieved with the special effect of photo collage. You can convert photos into a grid composition or (my favorite) double expose photos for interesting effects.

Artistic Effects

There are a variety of other effects you can do with your digital photos and a few software tricks. One effect I like to create is posterizing, which gives very graphic effects to your photos.

Pictured clockwise from top left:
- Photo collage, double exposure
- Photo collage, double exposure
- Artistic (posterized)

DISPLAYING
YOUR PHOTOS

There is no better way to personalize and add cheer to your home than with displays of photos. Whether they are vintage photographs of family members or bright examples of recent events, personal photos give your home an affordable, friendly look. Use the examples on the following pages as inspirations for creating your own groupings. Hanging how-to tips and hints follow.

TABLESCAPE GALLERY

Favorite photographs grouped on a tabletop, piano, or shelf make a striking home accent. Here, larger photos in simpler frames are arranged behind smaller photos in more elaborate frames. You can also include objects like a clock or place some photos on easels.

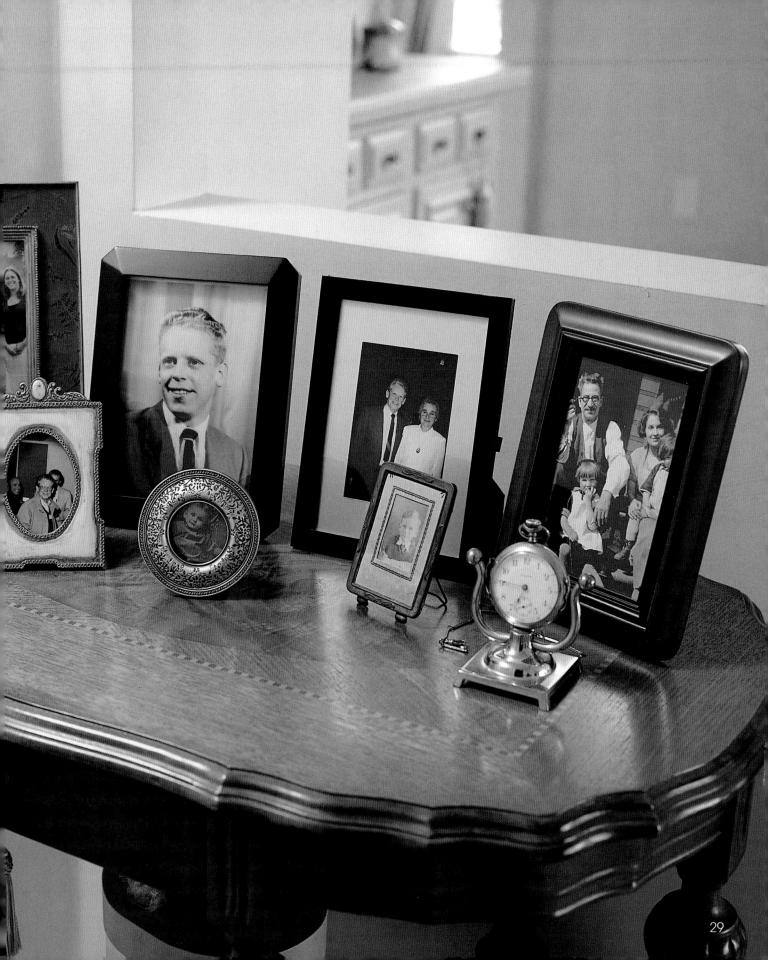

SOFA GALLERY

A sofa is an ideal anchor for a photo display. In this grouping, the mats and frames, which don't match, are brought together with a common subject – vintage family photographs. The display is not centered above sofa but is arranged asymmetrically for a casual look.

The center of the grouping is at eye level; the bottom edge of the first row of photographs is 7" from the top of the sofa. You can place photographs as close as 6" from the top of the sofa to accommodate the size of your collection.

TIP: Always use the room size as a guide to the size of your photo display. Large rooms can visually handle a larger display; small rooms need only a few photographs to create visual impact.

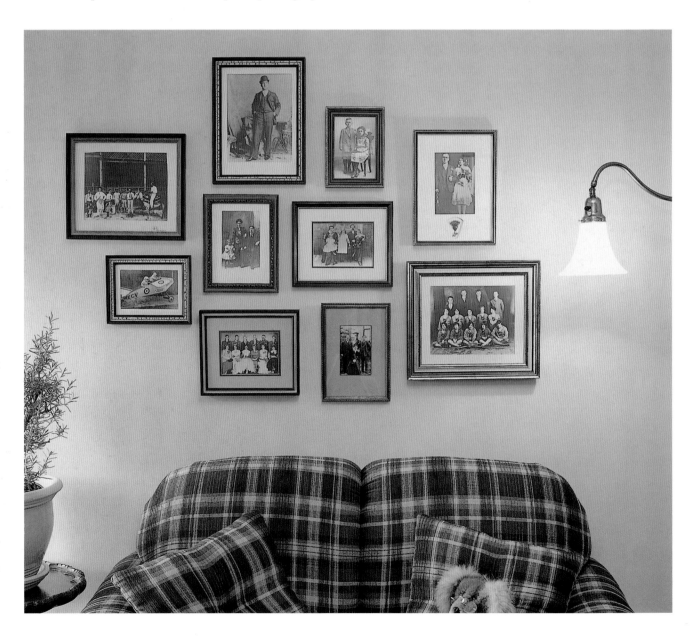

SHELF GALLERY

To make a visual impact, try grouping similar photographs together. For even more emphasis, use the same frame and mat color. In this example, a group of favorite family photographs, printed in black and white, is presented in simple, inexpensive glass clip frames and matted in a color that matches the room's decor. The photographs rest on shelves so the arrangement can be changed easily.

Instant lettering decals add a fun accent to this display. Follow the package directions to install the lettering in your choice of a saying or descriptive journaling.

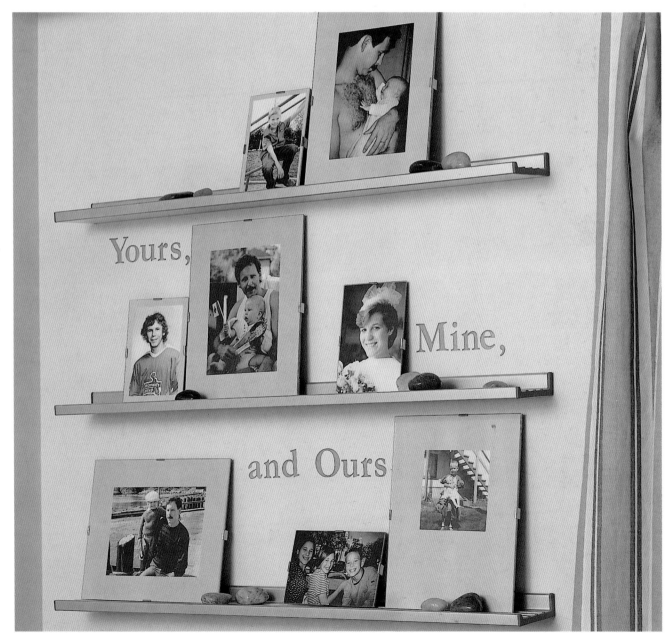

SPORTS THEME GALLERY

Whether your family members are fans or players, sports theme walls are a great way to add a visual story to a family room or den. This example uses team photos, a jersey, sports equipment, and trophies.

To display a jersey, frame it or hang from a dowel supported by two coat hooks. Rackets, snowshoes, or lacrosse sticks can also be displayed on coat hooks. To hang items such as hockey sticks, baseball bats, and golf clubs, wrap them with a piece of picture wire, securely twist the wire together to form a loop, and hang on a standard picture hanger.

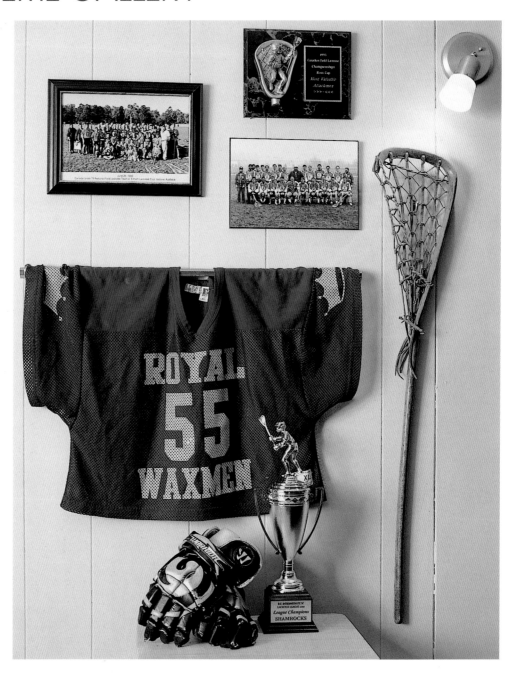

MANTEL GALLERY

Holidays are a great time to display past celebrations. This mantel display uses glass candle cylinders to provide a glowing show of photographs printed on clear transparencies. Vellum helps diffuse and soften the light. See the Holiday Candle Holders project for instructions.

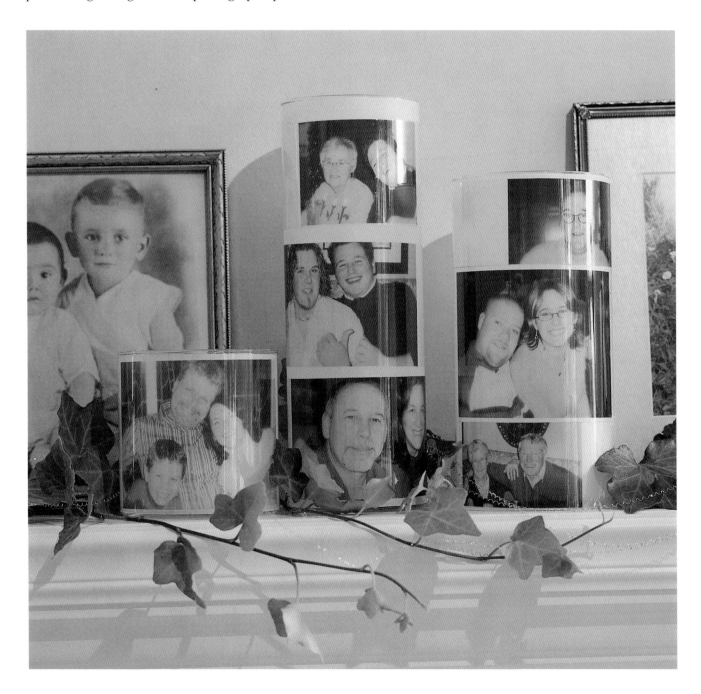

HANGING YOUR PHOTOS

One of the great mysteries of life is how to properly hang a picture on the wall without making extra unsightly holes. A properly hung photo display can change the focal point or the entire look of the room. Hanging photos, especially a large display with numerous pieces, is easy when you follow these simple hints.

Tools
- Tape measure (for horizontal and vertical measurements)
- Stud finder
- Pencil
- Picture hanging hardware
- Low-tack masking tape, such as painter's tape
- Freezer paper *or* blank newsprint

Helpful Hints
- **Choose the right size hangers.** Make sure your picture hangers are appropriate for the size and weight of your framed photo. Hangers have pound ratings that ensure the hardware can carry the weight of the picture.

- **Use two.** For large photos or pieces, use two hangers per picture. They will hang straighter and will not shift.

- **Use the right size nails.** Nails with big heads and a thin body make smaller holes in your wall. They also work best with plaster walls.

- **Find the studs.** Nail picture hangers into wall studs. The best way to do this is to use a stud finder, available at hardware stores and home improvement centers. You also can locate a stud by nailing a thin nail into the wall (you can feel the resistance when you hit the stud); you can find other studs by measuring at 16" intervals. Obviously, it's best to not have a series of small holes in your walls; a stud finder is a wise investment.

- **Don't hang too high.** A common mistake is hanging photos too high. They should be at eye level for best viewing. Art galleries generally use the 56" standard – 56" from the center of the picture to the floor is eye level for the average person. In homes, the 56" standard is not a hard-and-fast rule as we have sofas, tables, windows, and doors to work around.

Hanging Groupings
For large displays or small displays that require perfect placement, use this technique for guaranteed success.

1. Lay sheets of freezer paper or newsprint on the floor slightly larger than the finished grouping to make a template for your display. If needed, tape the sheets together with masking tape.

2. Position the photos on the paper on the floor in your desired arrangement. Leave ample room between each picture – usually a hand's width or 3" to 4" is adequate. (Leaving too-small spaces between photos is a common hanging error.)

3. Trace around each element of the arrangement with a pencil.

4. Working one picture at a time, remove the picture and measure to determine its hanging point (where the hanger needs to be relative to the picture wire) and mark with an X. (Picture wires generally are 2" to 3" from the top of the frame, but can vary in placement.) Mark each picture.

5. Position the template on the wall and affix with low-tack masking tape. TIP: Use the 56" rule – hang the center of the grouping 56" from the floor. If you're placing your display above a table or a sofa, allow 6" to 8" from the top of the furniture piece to the bottom of the first photo.

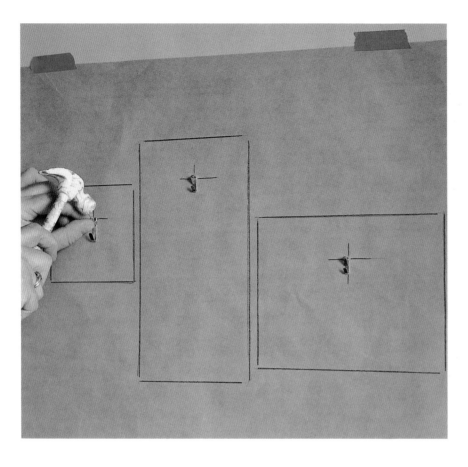

6. Install picture hangers where indicated by the X marks. Tear away the paper template.

7. Hang your pictures on the hangers for a perfect display.

Nailing hangers in a wall where indicated on freezer paper template.

Use photos with other objects or arrange your photos around an item.

Asymmetrical arrangements energize modern or casual interiors.

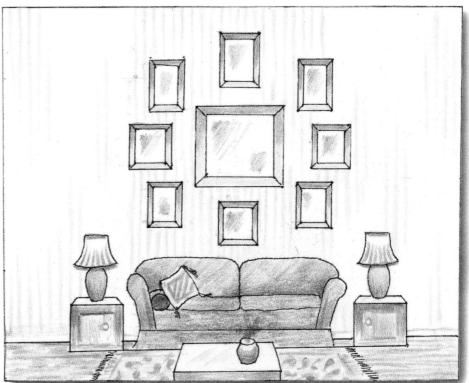

Pictures hung vertically add height and drive the eye upwards.

Pictures hung in a horizontal row visually widen a space.

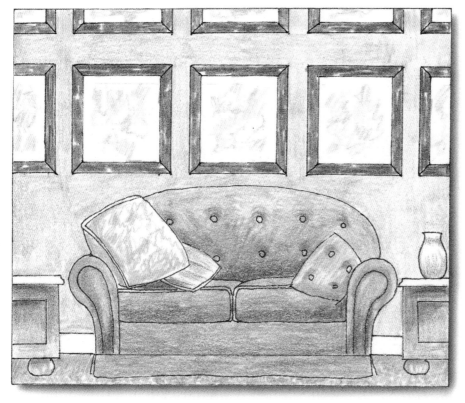

Symmetrical arrangements denote formality.

EASY PHOTOCRAFTING
IDEAS

This chapter includes information about basic photocrafting supplies and techniques like cutting, cropping, gluing, coloring, and embellishing – familiar techniques from the craft of scrapbooking, from which photocrafting has emerged. A variety of simple projects illustrates the techniques and will help get you started.

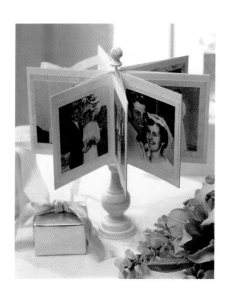
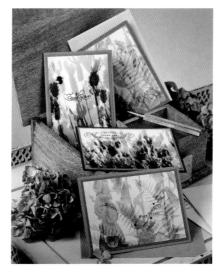

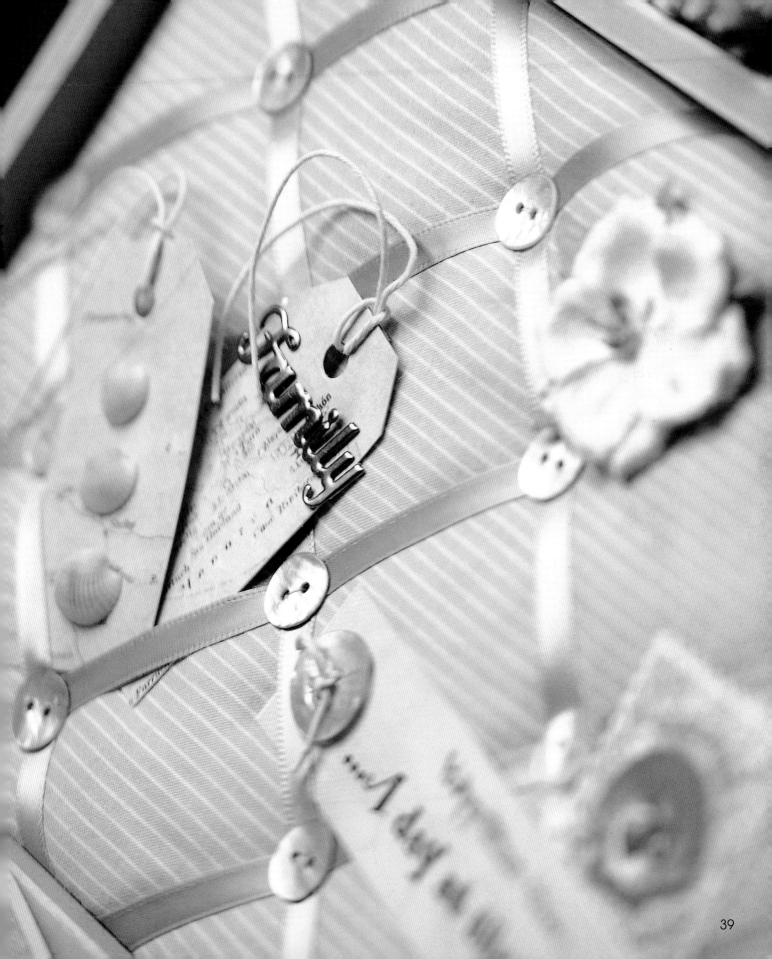

Tools & Materials

Craft Knife

A scalpel-type **art knife or craft knife** with a replaceable pointed blade is essential. It is an all-purpose knife for trimming photographs and cutting card stock. Have additional blades so you'll always have a sharp cutting edge.

Paper Trimmer

A **paper trimmer with a sliding cutting blade** is a basic tool for photocrafting. Both cutting and scoring blades are available.

Scissors

Sharp craft scissors are needed for decorative treatments such as decoupage. **Decorative-edge scissors** are useful and fun to use for decorative cutting and creative trimming.

Cutting Mat

A **self-healing cutting mat** with a printed grid protects your work surface and helps you make accurate cuts. The mat's surface seals itself after each cut so your knife won't follow a previous cut. The mat is marked with 1", ½", and ¼" grids make measuring and cutting perfectly square corners a breeze. Cutting mats range in size from 9" x 12" to ones that will cover an entire tabletop. Buy the biggest mat your budget will allow.

Ruler

A straight edge **metal ruler with a cork backing** is needed for guiding perfectly straight cuts. Don't substitute a wooden or plastic ruler – they will slide and your knife will cut into them. A 12" ruler is suitable for all the projects.

Cutting Template System

A **shape cutter with shape templates** and a cutting mat are useful for quickly cutting out shapes and cropping photographs.

Paper Punches

Available in a wide array of sizes and designs, **paper punches** cut intricate paper shapes and motifs. Special types of punches can be used to uniformly trim corners.

Bone Folder

A **bone folder** is indispensable. Use a bone folder to remove wrinkles and creases quickly, to create a firm bond between paper and a surface (pressing the paper with the smooth sides), and to score lines for folding.

Sanding Block

A **sanding block** works faster and gives cleaner results than a handheld sheet of sandpaper. Use fine to medium grade sandpaper – 100 grit works well for sanding paper flush to an edge and for creating a distressed finish.

Adhesives

Glue Dots

Sticky **glue dots** are available in a variety of sizes, from very tiny (1/8") to larger (½") in both round and square shapes. Some glue dots are pieces of foam with adhesive on both sides; others are dimensional clear dots on a protective paper roll.

Double-sided Tape

Use **double-sided tape** for adhering paper to paper and paper to wood.

Glue Stick

Inexpensive and easy to use, a **glue stick** is best for gluing paper to paper. When working with a glue stick, use gluing sheets (e.g., wax paper, deli sheets, or pages from an old phone book) to keep the fronts of your images free from excess glue.

Craft Glue

Thick, tacky **white craft glue** is used when applying heavier embellishments because it creates a much stronger bond than a hot glue gun. **Specialty craft glues**, such as jewelry glue and wood glue, work even better in some applications, such as jewelry glue for adding embellishments to a metal surface. These glues are white when wet and dry crystal clear.

Decoupage Medium

When gluing paper to wood, metal, or canvas, use **decoupage medium.**It is white when applied but dries clear.

Thin-Bodied White Glue

Thin-bodied white glue contains latex, which is essential for sealing paper pieces prior to applying a polymer coating. The seal coat prevents the resin from leaving dark spots. This glue goes on white and dries crystal clear. **Do not** substitute a decoupage medium for the seal coat – most are diluted. They work great as a glue for paper pieces but do not contain enough latex to seal paper properly.

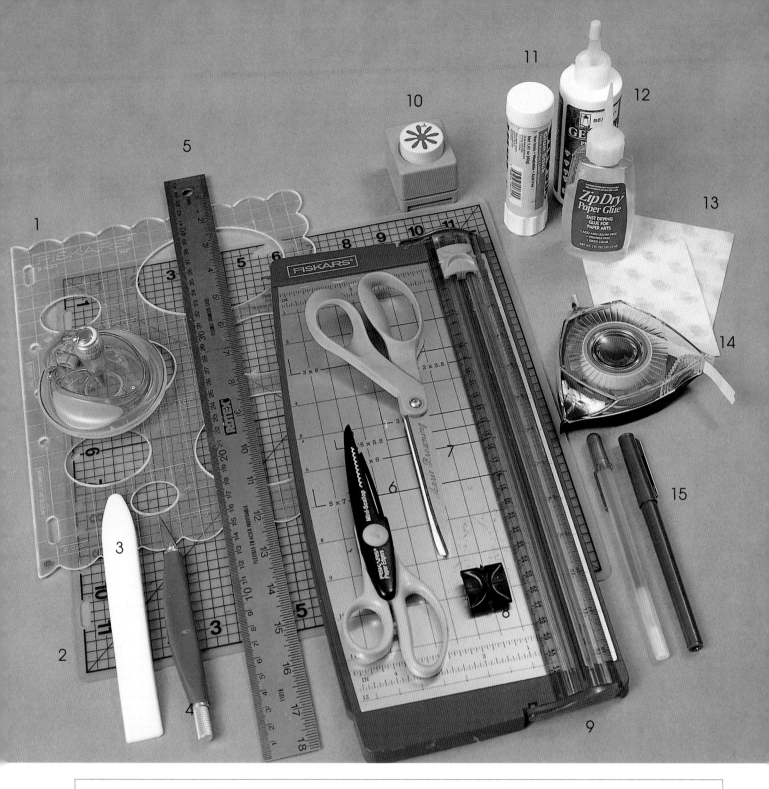

Pictured above:
1 – Shape cutter & templates
2 – Cutting mat
3 – Bone folder
4 – Craft knife
5 – Metal ruler
6 – Decorative-edge scissors
7 – Scissors
8 – Scoring blade for slide trimmer
9 – Slide trimmer
10 – Paper punch
11 – Glue stick
12 – Paper glue
13 – Glue dots
14 – Double-sided tape
15 – Pens for journaling

Tools & Materials, continued from page 40.

Ephemera

Photocrafts artists especially prize ephemera – "pieces of paper from everyday life" – to use in their designs. You can find old ephemera in secondhand and antiques stores or newly reprinted on scrapbook paper and gift wrap. Whole books offering one-sided pages of interesting ephemera can be found at crafts and scrapbooking stores, ready to cut and use. Or raid your attic for old letters, postcards, and family records or consider handwritten love letters, pages from old books, old documents, and everyday items such as tickets, labels, and certificates. If you don't want to use a precious or one-of-a-kind item or image, color photocopy or scan and print it. **Always** copy valuable pieces rather than using the original in your project.

Decorative Papers

Decorative papers come in a huge assortment of colors, designs, and textures. In just one walk around a scrapbooking, crafts, or art supply store you will discover many papers that inspire your creativity. Many different types of decorative papers can be used for photocrafting projects.

Embellishments

Tag Frames

Small metal frames are available in a variety of shapes and sizes for creating custom tags.

Brads

Decorative and plain brads are fasteners with metal prongs that spread behind the paper.

Chipboard Letters & Shapes

These thin, durable cardboard pieces can be plain or decorated.

Ribbons & Fibers

Choose from a wide variety of wire-edge, grosgrain, sheer, and satin ribbons, printed binding tape, yarns, and threads.

Rub-ons

Letters, words, and quotations can be transferred to many different surfaces. They are perfect for photocrafting – the image shows through. You'll find a variety of trendy designs.

Stickers

Stickers offer an instant piece of artwork that you simply peel and stick on your composition. The selection is huge! Look for alphabet stickers, fine art stickers, vintage labels, and quotes printed on vellum.

Acrylic Paint

Acrylic craft paints are a crafting staple used for basecoating surfaces. They are easy to find in crafts and art supply stores.

Pictured opposite page:
1 – *Parchment flowers*
2 – *Buttons*
3 – *Printed ribbon*
4 – *Ribbon buckles*
5 – *Clips*
6 – *Metal embellishments*
7 – *Ribbon*
8 – *Metal tags*
9 – *Metal letters*
10 – *Brads*
11 – *Tag frames*
12 – *Photo clips*
13 – *Label holder*
14 – *Tag charms*
15 – *Quotes on clear paper*
16 – *Metal corners*
17 – *Rub-ons*
18 – *Clear plastic letters*
19 – *Stickers*
20 – *Metal letters*
21 – *Charms*
22 – *Novelty charms*
23 – *Decorative paper*
24 – *Card stock*

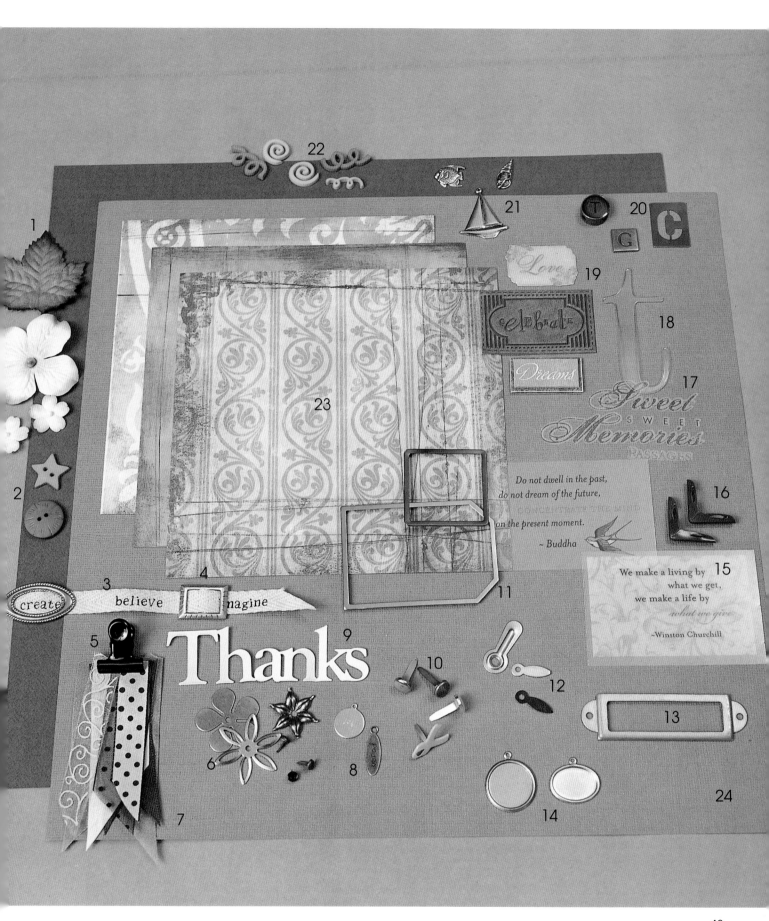

Cutting & Cropping

Cutting and cropping are the first steps to perfect projects. Having the right tools makes all the difference.

Using a Paper Trimmer with Sliding Blade (see page 40)

For general trimming, a slide trimmer is the easiest and fastest way to crop pictures. It is very hard to cut a straight line with scissors, so a slide cutter is a very valuable tool when photocrafting for cropping photos into squares and rectangles. To make a clean cut, lift the cutting arm and slide your photo flush to the top of the trimmer. This insures a perfect square cut. With a slight bit of pressure, pull the blade down as you complete the cut. If you are not getting a clean, crisp edge, you may be applying too much pressure or you need to change the blade. Many trimmers allow cutting multiple sheets, but I trim one photograph at a time for best results.

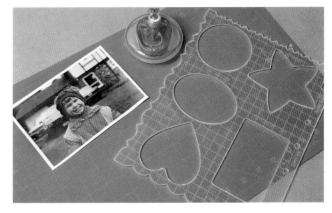

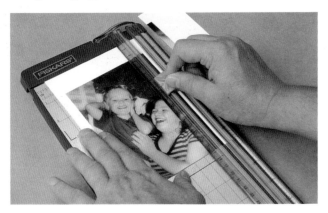

Using a Shape Cutting System

Cutting your photographs into circles, stars, or other creative shapes adds a special touch. Many shape-cutting systems are available. I like the palm sized cutter that you glide around a template shape. You will need a cutting mat to protect your surface when using a shape cutter. Some cutters allow you to adjust the blade depth for the paper thickness. Apply a little pressure and cut in a clockwise direction making sure the blade is facing the direction of the cut. You also have to make sure the template is right side up for perfect, tear-free cutting.

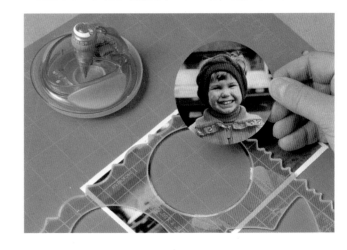

Trimming Edges Flush with a Surface

You can trim your images to exactly fit a surface by sanding the edges. This gives a neat, precise, professional-looking edge to your projects. Cut the image at least ½" larger all around than the surface. With decoupage medium, adhere the image to the surface and let dry completely. Holding a piece of 100-grit sandpaper at a 45-degree angle to the edge of the surface, sand the image, being careful not to scratch it, until the sandpaper cuts through the paper image. A sanding block makes the sanding faster and gives a neater edge.

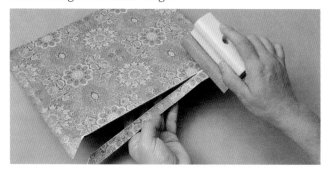

Cropping Hints

- When cropping a photograph, remove a background that does not improve or add anything to the image. This example shows how cropping helps to eliminate unwanted elements to produce a better photo. I like to use corner frames made from old mat frames as an aid to help me decide where to crop a photo. Adjust the frames for the best view, make small cutting marks and then cut with a slide trimmer.
- Highlight the focal point of the photograph without crowding it. The original photo, at left, was cropped and enlarged. Cropping out the excess forest area did

not distract from the mood of looking through the trees to the ocean.

- When cropping people, the goal is to remove the excess evenly. For example, don't make the mistake of cropping out the feet, but allowing too much space above the head. In most cases it is best to not cut off feet or crop into or too close to the heads. But, there are always exceptions as shown in this example. For this photo of mother and child, the feet were cropped and the cropping is close to the mother's head so that I could get really close for a more intimate look at the child.

Original photo

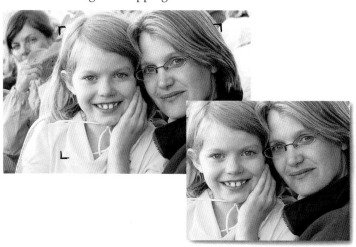

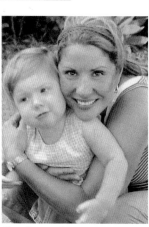

Poorly cropped *Good cropping*

Cropping Hints, continued from page 45

- This photo was cropped extremely close, cropping off part of the head so that the photo could focus on the crab the child is holding.

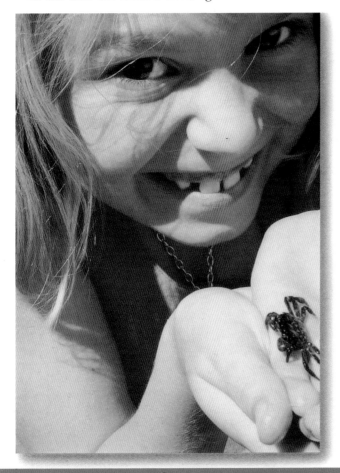

- It can be effective to cut figures out of the background to use them for decoupage. Choose photos with simple, large shapes and clear, easy to cut outlines. Use sharp crafting scissors and cut carefully. TIP: It is much easier to cut images from a photocopy than from an actual photograph. Stay away from profiles and hard to cut details such as flowing hair. Individual figures allow you to have more options when arranging your composition.

Not a good choice for cutting out figures because of hair and limbs not showing.

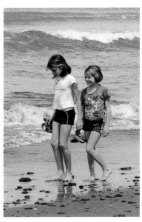

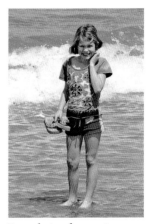

Not a good choice because of the profiles.

Best choice for cutting out a figure.

As this scrapbook page shows, with creative cropping and cutting, you can create exciting photo arrangements that tell a story even before you add journaling and embellishments.

46

Gluing Techniques

Move pieces around and arrange your composition before gluing them down. When you are happy with the arrangement, then permanently adhere them to the surface. Use the recommended glue for the best results. When gluing paper to paper, use a glue stick. When gluing paper to wood, metal, or canvas, use decoupage medium. For adhering heavier items (embellishments, fabric, ribbon, etc.) to any surface, use all-purpose white craft glue.

1. For regular weight paper pieces, use freezer paper or wax paper to protect your work surface. Lightly coat the back of the image with the decoupage medium glue. Work from the center of the paper piece to the outside, making sure you have glue on all the edges and an even coating of glue on the paper. Too much glue will cause excessive wrinkling that cannot be corrected.

2. Lift the paper piece and place on the surface.

3. Carefully smooth the image, removing wrinkles and bubbles with your fingers.

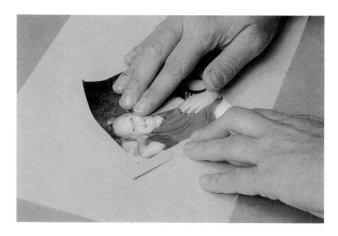

Option: Use a bone folder when working on a paper base. Larger pieces are most likely to have bubbles and wrinkles so it is important to work fast. Let the glue dry before proceeding.

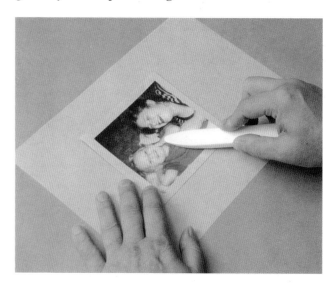

Color Tinting Photographs

Hand coloring can bring extra brilliance to an old photograph and improve new prints by adding soft color. In this book, I used three techniques that are easy, require no experience, and produce great results the first time. When tinting, you need not shade or worry about producing different tones – the photo already has those. You are merely adding a layer of color. By keeping the colors transparent and the application smooth, you can easily give photos a realistic colored appearance.

Photo Oil Paints

Photo oils are intended for use on black-and-white or sepia photos that are produced by standard photo processing on matte finish photographic paper. (If you use other papers not specifically designed for hand coloring with photo oils, the color will not adhere properly to the surface.) Transparent photo oil paints are acid free and will not fade over time or harm your photograph. You can use the actual tinted photo for your project or make a color photocopy.

Supplies: Photo tinting oils; Plastic eraser; Matte finish photograph (standard photo finishing or printed on photographic paper); 100% cotton balls and cotton-tipped swabs; Palette or white foam plate

Here's How:
1. Squeeze a small amount of each color on your palette. Apply the paints sparingly to the photo, working one small section at a time, using a different cotton swab for each color. Begin with the lightest color that will be used over the largest area, and apply the paint to the photo, gently rubbing the area to cover it with a thin layer of color.
2. Using a cotton ball, softly smooth out the color, removing any excess paint so that the appearance is that of an evenly coated, transparent stain. Let dry 48 to 72 hours, depending on humidity and the thickness of the paint.

• Colors can be adjusted or lightened by using a clean swab or cotton ball to remove color or to blend additional colors in thin layers.
• Use deep and light colors as well as complementary colors and multiple shades of the same color family to add realism. (For example, using several shades of green paint on leaves or foliage will more closely resemble nature.)
• You can easily remove color from the surface of the photo before the paints dry with a plastic eraser.

Photo Tinting Pens

These pens, for hand coloring black and white photographs, are fun and easy to use. They work on both glossy and matte surfaces and contain transparent dyes that actually penetrate the emulsion and become part of the print. The dyes dry in about half an hour and the finished print requires no protective coating. You can use the actual tinted photo for your project or make a color photocopy.

When selecting a photograph to tint, chose one with large elements and good contrast of light and dark areas. Use lighter pens on white areas and darker colors on the deep shadows and black areas. When you first use a tinting pen, you must soften the tip so it won't scratch the emulsion of the print and the color will spread evenly.

Supplies: Photo tinting pens; Remover pen; Pre-moistening solution
Sponge; Glossy or matte finish photo prints (standard photo finishing *or* printed on photographic paper)

Here's How:
1. If the pen is new, soften the tip by rubbing it vigorously on a piece of card stock for about 60 seconds.
2. Dilute 1 teaspoon of pre-moistening solution with 32 ounces of water. Prepare the print by sponging the pre-moistening solution on the surface.
3. Starting with the largest element in your photograph, apply the dye in light circular strokes, gradually building up the color. It may take several applications to build up the desired color intensity.
4. When you are finished and satisfied with the coloring, sponge the whole print with a light coating of pre-moistening solution. Let air dry for 30 minutes.

• If you make a mistake, immediately use the removal pen to correct it. Once the dye has set, it is permanent and impossible to remove.
• When coloring faces, don't color the teeth or the whites of the eyes.
• Keep the photograph moist by re-applying the pre-moistening solution as needed.

Tinting Photographs with Acrylic Paint

This technique, which achieves the nostalgic look of old tinted photos, uses a transparent paint medium on photocopied prints. The method is easy to do and quite inexpensive, and it's easy to correct mistakes.

Supplies: Photograph; Acrylic paint and gel medium; Decoupage medium; Acrylic varnish; Palette *or* white foam plate; Palette knife; Paint brushes in a variety of sizes

Here's How:

1. Copy your photograph on a color copier in black and white or sepia. If it's a color print, photocopy it on the black and white setting on a color photocopier.
2. Adhere the photocopy to your project surface with decoupage medium. Let dry.
3. Apply an even coating of acrylic varnish to seal the print. Let dry.
4. On your palette, Use a palette knife to mix each color of paint you plan to use with an equal amount of gel medium.
5. Apply a light coating of the paint mixture with a brush. The result should be a light, transparent wash with visible shadows and highlights. Let dry completely.
6. Brush with a coat of acrylic varnish. Let dry.

- If you cannot see the photo's details, you are applying too much paint or you need to add more gel medium.
- If you make a mistake, use a damp cotton swap to gently rub the color away. ❏

Pictured opposite, clockwise from bottom left:
1 – Photo tinting with photo oils
2 – Tinting with acrylic paints
3 – Tinting with photo tinting pens

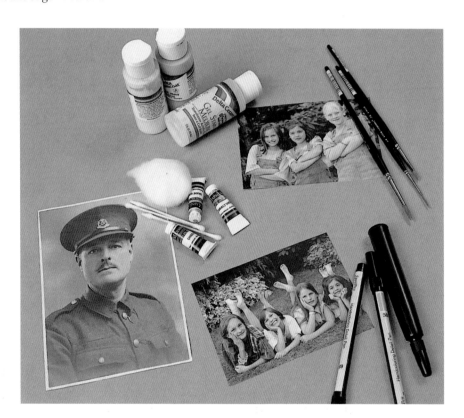

BEACH VACATION
BOX

Pictured on page 50 & 51
Instructions begin on page 50

A beach vacation is remembered with a mini scrapbook and a box to hold mementos.
This is a great way to show off photographs along with souvenirs and small objects.
I glued sand inside the box for a decorative accent; the shells are not glued down. This
type of box could also hold mini scrapbooks commemorating special events.

Beach Vacation Box, continued from page 49

SUPPLIES

Project Base:

Wooden box, 6¾" x 10½" x 2"

Decorative Elements:

Wood or ceramic tiles, ¾" square

Stickers – Square number and letters (to fit tiles)

Photo, 8" x 10", photocopied on a color photocopier

Mat board, 6¼" x 9¾" (or to fit inside the lid of your box)

Coordinating fabric, 8" x 10"

Polyester batting, ½" thick

Acrylic craft paints – Light tan, light aqua green

Acrylic varnish, matte finish

Satin ribbon – Tan, ¼" wide

15 mother-of-pearl buttons

Box embellishments – Shells, sea glass, mini souvenirs, tags, journal panels, parchment flower

Coral sand

Other Supplies & Tools:

Decoupage medium	Double-sided tape
Brush	Masking tape
Wax	Awl
Sandpaper, 100 grit	Heavy thread, and needle
White glue	

For the mini scrapbook:

Tan card stock, four 6" x 12" panels (for the pages)

Light green card stock, two panels 5" square

Matching decorative paper

Photographs, printed to size and trimmed with decal-edge scissors

Journaling on transparent paper

Small brads

Glue stick

Natural twine

Plastic shell buttons

Computer and printer

INSTRUCTIONS FOR THE BOX

Paint the Box:

1. Remove the hardware from the wooden box.
2. Rub areas of the box randomly with a piece of wax.

3. Paint the outside of the box with one coat of light tan acrylic paint. Let dry.
4. Sand to create the weathered look. Wipe away the dust.
5. Basecoat the inside bottom of the box with light aqua paint. Let dry.
6. On the inside bottom of the box, brush glue at two corners and, before the glue dries, sprinkle with coral sand. Let dry. Dump out the excess sand.
7. Coat the entire box, inside and out, with matte varnish. Let dry.

Embellish the Lid:

1. Trim the 8" x 10" photo into squares and rectangles, using the project photo as a guide. (The way you trim the photo will depend on the subject matter.)
2. Arrange the photo pieces on the box lid, leaving spaces between the pieces to create the mosaic look.
3. Add the number and letter stickers to the tiles and add them to the arrangement.
4. Glue the tiles in place with white glue.
5. Adhere the photos with decoupage medium.

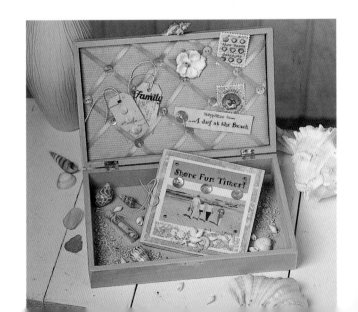

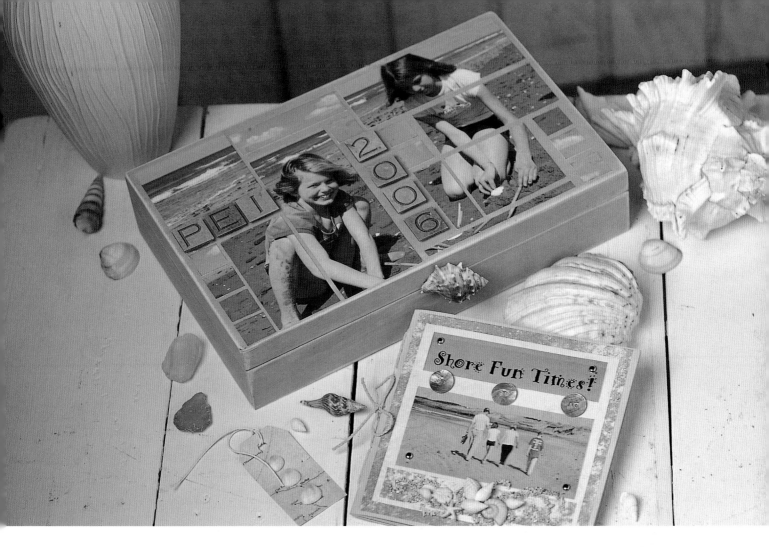

Line the Lid:

1. Glue the polyester batting to the top of the mat board.
2. Cover the board and batting with fabric and secure on the back with double-sided tape.
3. Cut pieces of ribbon to create a lattice pattern on the padded mat board. Position the ribbon pieces and secure them to the back of the board with masking tape.
4. Using an awl, make a hole through the ribbons and mat board where the ribbons intersect. Sew a button at each hole, pulling the thread tightly and securing it on the back with masking tape.
5. Use white glue to adhere the fabric panel to the inside of the lid. Use a heavy book to weight it down while drying for a secure bond.

Finish the Box:

1. Reattach the lid.
2. Glue a shell on the front for a handle.
3. Glue the decorative embellishments to the inside of the box. ❏

INSTRUCTIONS FOR THE MINI SCRAPBOOK

The finished book will have 14 pages, a front cover, and a back cover.

1. Fold the four tan panels in half to create the 6" x 6" pages.
2. With an awl, punch five evenly spaced holes into the spine.
3. Using natural twine and a large-eyed needle, sew the pages together. Knot the twine and tie a bow to finish.
4. Set up pages for journaling in your computer with 4¾" square borders. Print out with an inkjet printer.
5. Cut the panels to 5" x 5".
6. Type additional journaling in the form of sayings on the computer and print out on clear transparent paper.
7. Glue the photographs in place on the green panels.
8. Attach the transparent panels to the green panels with small brads.
9. Use a glue stick to glue the finished panels to the book pages.
10. Decorate the front and back covers with decorative paper panels, transparent panels, a photograph, and buttons. ❏

BRAG BOOKS

These little brag books are an easy, fast scrapbook design. You can add as many as eight pages or leave it at four. The examples show two very different themes, but the sizes and format are the same. Choose decorative papers and colors that coordinate with your photos.

Changing photographs with special effects from a photo-editing software program can create a better fit with the moods, designs, and color choices of the books. The photographs for the Cameron Book were printed in sepia-tone with the grain increased; they work nicely with the denim colors and subtle cowboy theme. The photos of Baby Jojo were color focused on her face to remove the brightly colored background and now work beautifully with my chosen decorative paper.

SUPPLIES

Basic Book Supplies:

Card stock, 11" x 4½" (for the cover)

2 pieces card stock, each 4" x 8½" (each piece is two pages)

Decorative paper to coordinate with your theme

Photographs cropped to 3" square

Hook-and-loop fastener self-adhesive button (one set per book)

Embellishments:

For the Baby Book

Silk flowers in colors to match decorative paper

Brads

Punched flowers from card stock in matching colors

Panels with journaling

For the Cameron Book

2½" letter "C" with denim paint finish (See Chapter 9, "Faded Jeans Finish.")

Stickers

Punched letters

Blue square brads

Other Tools & Supplies:

Bone folder *or* paper trimmer with scoring blade

Glue stick

Double-sided tape

INSTRUCTIONS

1. Score the cover at 3¼", 4¼", and 3½". Fold on the scored lines, folding both flaps toward the center.
2. Decorate the front cover (the flap on your left) with pieces of decorative paper and other embellishments. Use the project photos as guides.
3. Use double-sided tape to attach the page panels together, overlapping them ½" at the seams. Score and fold to create the 4" square concertina "pages."
4. Cut the decorative paper into panels to decorate the pages, using the photo as a guide. Glue in place on the pages.
5. Attach the pages to the cover by gluing the back page on the center panel of the cover.
6. Glue the cropped photographs and journaling to the pages.
7. Further decorate the book by adding decorative paper panels to the right cover flap and inside flaps.
8. Position the hook-and-loop fastener button pieces to the inside of the left flap and the outside of the right flap, lining them up to make the closure. ❏

The Best Blooming Baby!

Julie and Rod

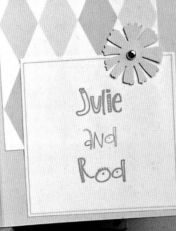

our little girl
Joanna Marie
February 4, 2005

8 lb 12.5 ounces
21 inches

CAMERON

best

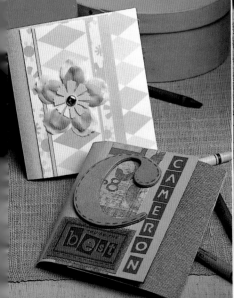

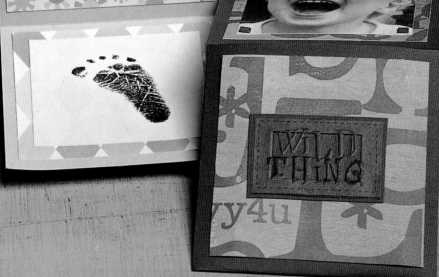

WILD THING

WEDDING PHOTO
CENTERPIECE

This paper centerpiece becomes a keepsake after the wedding – simply untie the ribbon, pull out the dowel, and remove the stand to create a mini scrapbook. I filled mine with vintage and modern wedding couples printed in black and white. You could also make the centerpieces with childhood photos of the bride and groom, or use photos of the couple throughout their marriage for an anniversary celebration.

SUPPLIES

Papers & Decorative Elements:

12 sheets card stock in pastel colors, 8½" x 11"

12 panels matching decorative paper, 4¾" square

12 black and white photographs, cropped to 4" square

Stickers to match

Silk ribbon, ½" wide, four 12" lengths

2 wooden discs, one 2¼", one 2"

1 wooden finial, 4½" tall

1 wooden finial, 1" tall

8" wooden dowel, 1/8" diameter

Other Supplies & Tools:

Double-sided tape

Wax

Sandpaper, 100 grit

White acrylic paint

Brush

Acrylic varnish, matte finish

Electric drill and 1/8" drill bit

INSTRUCTIONS

Make the Book:

1. Cut each sheet of card stock into 5½" x 11" pieces. Fold each panel into a 5½" square card.
2. Trim ½" off the right edge of six cards to make six cards that are 5" x 5½".
3. On the smaller cards, glue the decorative paper panels and photographs to the inside panels.
4. Using an awl, make three corresponding holes in the spines of the larger cards.
5. With waxed linen thread and a needle, sew the pages together at the spine using a bookbinder's stitch.
6. With double-sided tape, attach the smaller cards inside the larger cards with the right edges flush. (This creates the star design on the finished open book.)
7. With double-sided tape, adhere the card edges, leaving one edge unattached.

Make the Stand:

1. Glue together the 2¼" disc, the 4½" finial, and the 2" disc with white glue. Let dry. (This is the base.)
2. Drill a hole 2" into the center top of the finial. (This is for the dowel.)
3. Glue the small finial to the top of the dowel. Let dry.
4. Rub the wooden pieces randomly with wax. Paint with white acrylic paint. Let dry.
5. Sand the pieces to distress them. Wipe away the dust.
6. Apply a coat of matte varnish. Let dry.

Assemble:

1. Using double-sided tape, attach the ribbon pieces to the front and back of the book, aligning the ends.
2. Decorate the front and back covers with stickers so the stickers cover the ribbon ends.
3. Using three pieces of waxed linen thread, tie the book to the dowel. Knot and tie bows to finish.
4. To install the centerpiece, open the book, tie the ribbon in two bows, and place the dowel in the base of the stand. ❏

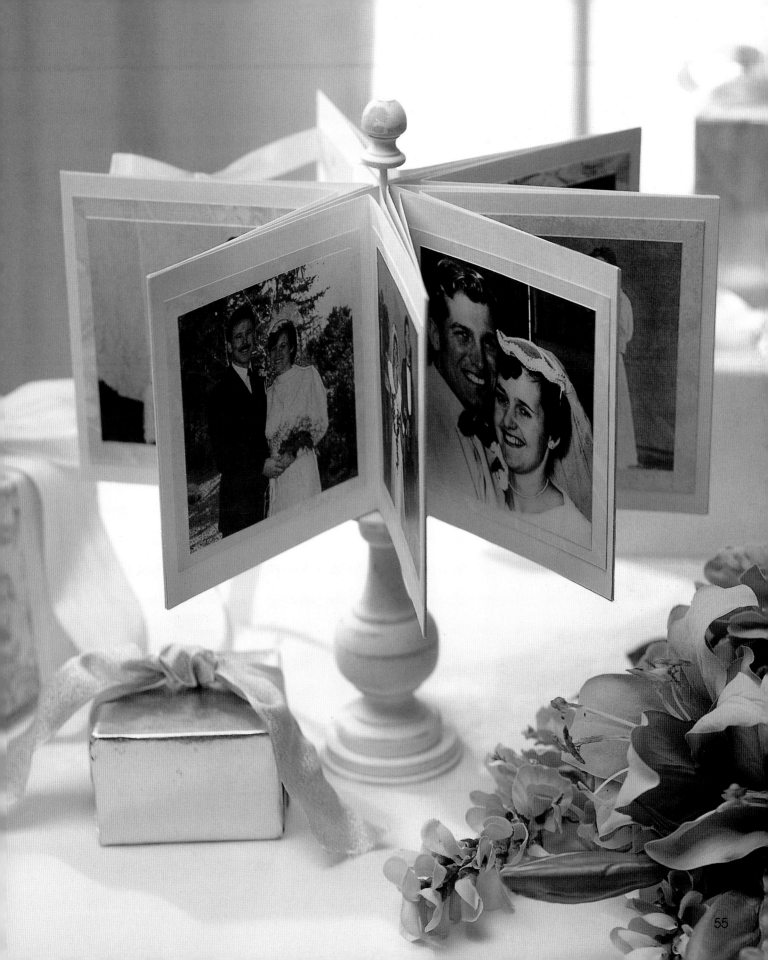

CLIPBOARD FRAME

This charming picture of Laura and Lisa is framed on a clipboard. It's decorated with scrapbook embellishments and the photo is protected with a piece of glass. Since the photo is attached with glue dots, it's easy to change if you wish. You can buy pre-cut glass (sold as replacement glass for frames) in standard sizes at art supply stores.

SUPPLIES

Project Surfaces:

Wooden clipboard, 6" x 9"

Glass, 5" x 7"

Decorative Elements:

Photo, 4" x 6"

Decorative paper, 5" x 7" panel

Clear decorative panel, 4" x 6"

White acrylic paint

Rub-ons – Swirls, words

1 yd. light green wire-edge ribbon, 1" wide

½ yd. peachy-tan wire-edge ribbon, ¼" wide

Silver charms

Other Supplies & Tools:

Double-sided tape sheet (or adhesive all-over applicator)

Glue dots

Wax

Sandpaper, 100 grit

Paint brush

Acrylic varnish, matte finish

INSTRUCTIONS

1. Remove the hardware from the clipboard.
2. Rub the wooden piece with wax. Paint with white acrylic paint. Let dry.
3. Sand the painted surface to distress.
4. Apply a coat of matte varnish. Let dry.
5. Reattach the hardware.
6. Attach the paper panel to the board with an all-over double-sided tape sheet.
7. Decorate the edges of the clipboard with decorative rub-ons, overlapping the motifs on the paper panel.
8. Using glue dots, attach the photograph and the clear decorative panel to the paper panel.
9. Place the glass under the clip of the clipboard, positioning it to cover the photograph.
10. Tie a bow with the green ribbon to the clip.
11. Wrap the peachy-tan ribbon around the other end of the glass to hold it in place. Tie the ends into a bow. Tie the silver charms to the ribbon ends. ❏

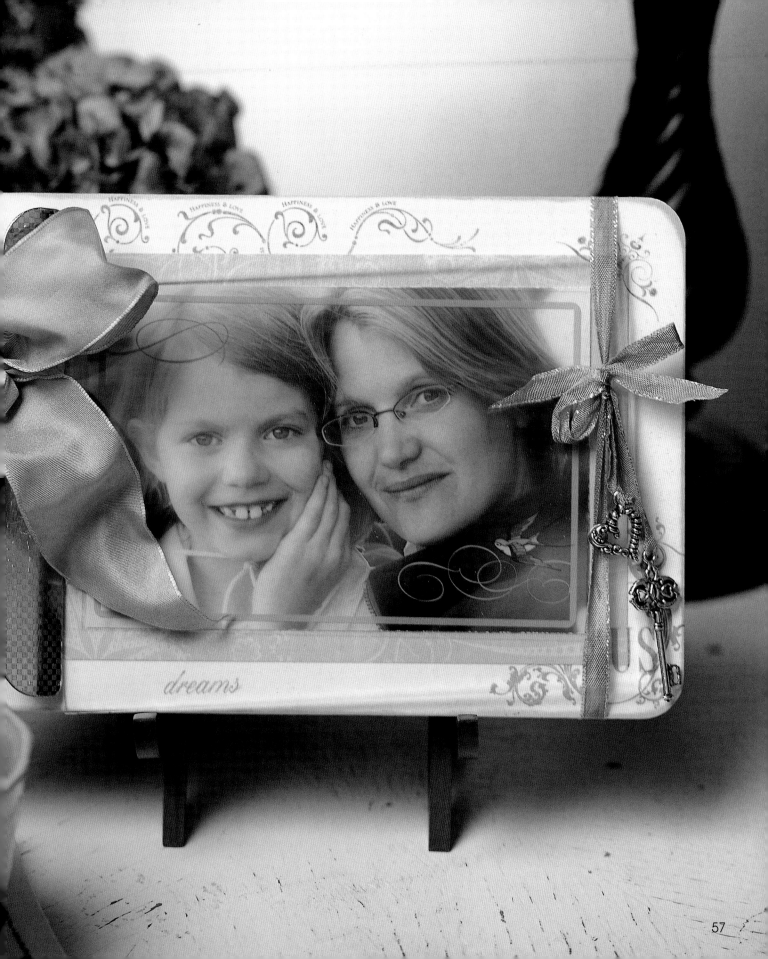

PHOTO COLLAGE
GREETING CARDS

These artsy cards were made using a creative effect available in many photo-editing programs. A double-exposure of two photos created the collage images – I found similar photos, ones with the same subject, colors, and theme, worked best with this effect. The colors in the photos influenced the card stock colors.

SUPPLIES

Papers & Decorative Elements:

Photos with double-exposure effect, printed on high gloss photo paper, 4" x 5"

Card stock, 9" x 6" pieces for vertical photos; 4½" x 12" for horizontal photos

Card stock in a coordinating color, 4¼" x 5½"

Rub-ons – "Thank you" or other sentiments

Other Supplies & Tools:

Glue stick

Bone folder

INSTRUCTIONS

1. Score and fold the card stock to create card blanks.
2. With the glue stick, mount the card stock panel on the front of the card blank.
3. Mount the photo at the center of the panel.
4. Add rub-on words on the photo. ❑

TIPS

• When photographing flowers in my garden, I place a white mat board behind the blossoms to take away the background. This helps "pop" the colors and removes the busy background.

• Choose an open spot in the photo for the sentiment – let the composition of the photo be your guide for placement.

• Try different card stock color combinations for different looks.

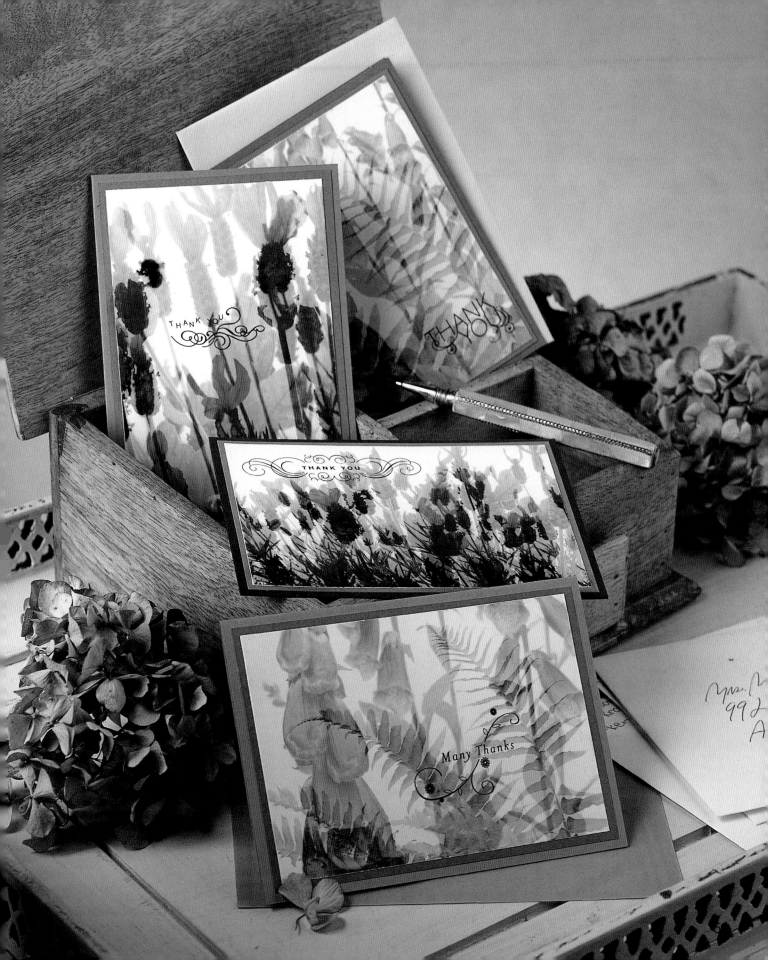

VINTAGE PHOTO BOWS

Vintage photos are reduced on a color photocopier in a sepia monotone, then cut into 1" circles with a shape template and shape cutter and mounted in bottle cap frames. Use them as holiday tree ornaments, wall decorations, party favors, or gift toppers.

SUPPLIES

For one bow:

Decorative Elements:

Vintage photo, reduced and color photocopied in sepia

1 yd. green or dusty rose satin ribbon, ¼" wide

Beading wire, 30 gauge

2 bottle caps

6 or 7 small parchment rosebuds

1 parchment leaf, 1¼" long

3" head pins

3" eye pins

Beads – pink, silver

Plastic leaf charm

Silver metal charm

Silver bullion

Scrap of colored paper

Tools & Other Supplies:

Glue gun and glue sticks

Hammer

Shape cutter with circle template

Needlenose pliers

Roundnose pliers

INSTRUCTIONS

Make the Parts:

1. Make a multi-loop bow with the ribbon. Use beading wire to wrap the middle of the bow securely.
2. Fold a piece of 10" ribbon in half and wire in the center of the bow, leaving a small loop at the top for a hanger. (You can use this loop to attach an ornament hanger.)
3. Take a 6" length of bullion and stretch it out. Form the bullion into a small multi-loop bow. Twist in the middle to secure. Fold in half to create the shiny accent.
4. Flatten the bottle caps with a hammer.
5. Use the shape cutter to cut a photo in a 1" circle. Glue the photo in the center of a flattened bottle cap. Cut a 1" circle from paper and add journaling (such as the name(s) of who's in the photo) for the center of the second flattened cap.
6. Thread a selection of beads on a head pin. Form a loop at the end and wrap the wire to secure the beads.
7. Thread beads on the eye pin. Add a charm to the bottom loop.
8. Gather up a bundle of rosebuds and twist the stems together. Thread the stems through the loops at the tops of the beaded pins.

Assemble:

1. Place the flattened cap with the journaling face down on your work surface.
2. Glue the bow, leaf, the bundle of rosebuds with beaded pieces, and the silver bullion to the back of the cap. ❑

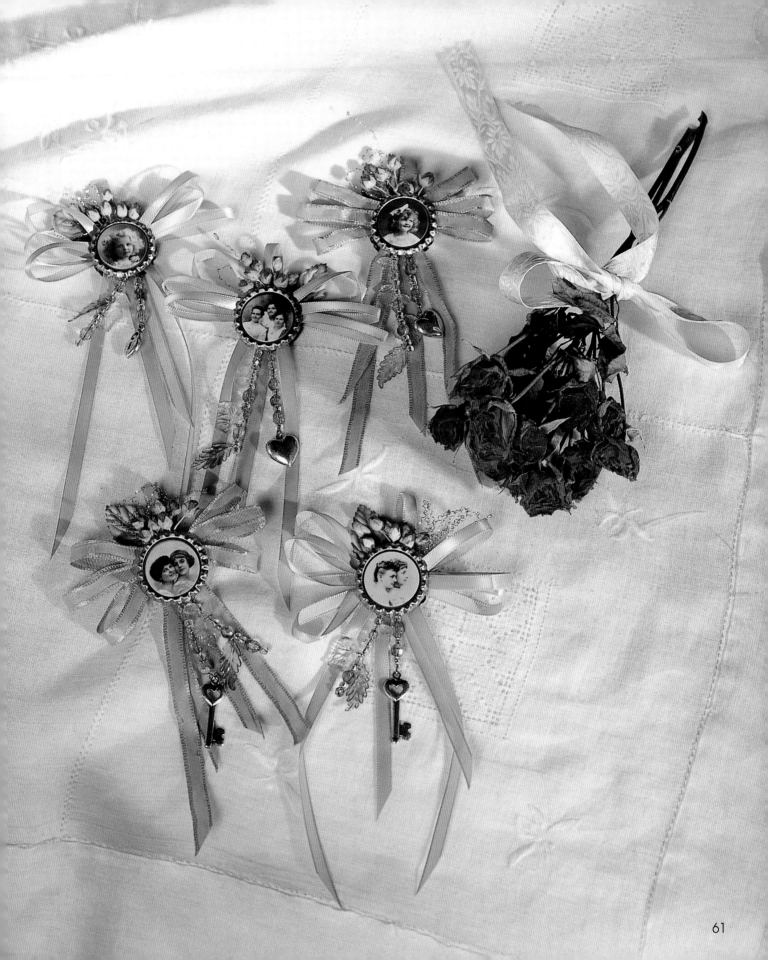

PHOTO INITIAL ORNAMENT

A contemporary photo was digitally changed to black and white and printed on vellum with an inkjet printer, then cropped to fit the silver frame. The frame and embellishments were attached to a painted chipboard letter. You could use the initial of the family name or the given name of the person in the photograph.

SUPPLIES

For one ornament:

Photo of your choice

4" chipboard letter

Silver memory frame with glass, 1½" square

Large silver brad

Black acrylic paint

Acrylic varnish, gloss finish

6" silver chain

Tag charms

Square crystal beads

Clear plastic leaf charm

2" silver eye pin

Silver jump rings

Rhinestone letter sticker

Large silver bail

Awl

Paint brushes

Needlenose pliers

INSTRUCTIONS

1. Paint the front and back of the chipboard letter. Let dry.
2. Varnish with gloss varnish. Let dry.
3. Place the photograph in the frame. Put the rhinestone sticker on the glass of the frame.
4. Fold the chain in half and attach to the frame's loop with a jump ring. Add a tag charm and a leaf charm to the ends of the chain.
5. Thread the beads on the eye pin and form the end into a loop. Attach to the chain. Add a tag charm to the bottom loop.
6. Pierce a hole in the chipboard letter and attach the silver frame with the brad.
7. Pierce a hole at the top of the chipboard and add the bail. TIP: Where you place the bail depends on what letter you're using. To experiment, hold the ornament between your index finger and thumb to determine the best place to pierce the hole for balanced hanging.
8. Hang the ornament by hooking an ornament hanger through the bail. ❏

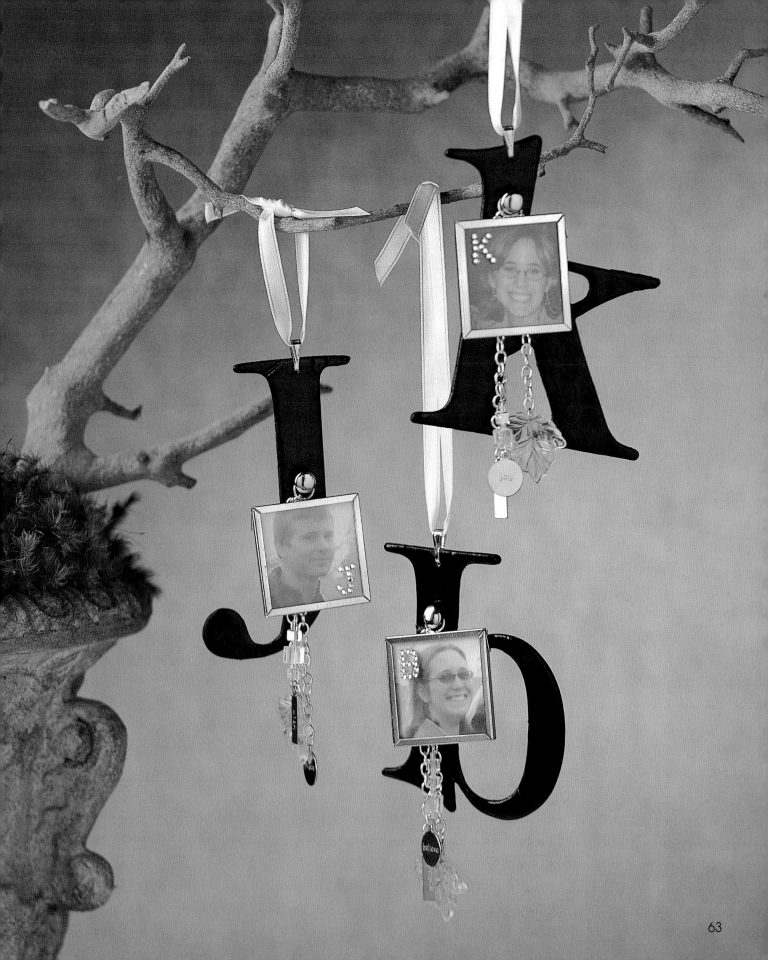

HOLIDAY CANDLE HOLDERS

Holiday photographs make a glowing mantel display when printed on clear film and paired with vellum to create the look of etched and printed glass. These photographs were digitally changed to black and white and printed on clear inkjet sheets.

SUPPLIES

Glass cylinder candle holders, variety of sizes

Vellum paper, 12" x 12" sheets

Photos printed on clear inkjet sheets

Double-sided tape

Clear tape

INSTRUCTIONS

1. Trim the vellum paper to fit the candle holders. Make sure the ends fit together with no overlap. Cut and attach a second piece of vellum if one piece isn't big enough to fit around the larger cylinder(s).

2. Tape the vellum pieces to the outsides of the cylinders with double-sided tape.

3. Trim the clear photo prints. Tape on the cylinders over the vellum. ❏

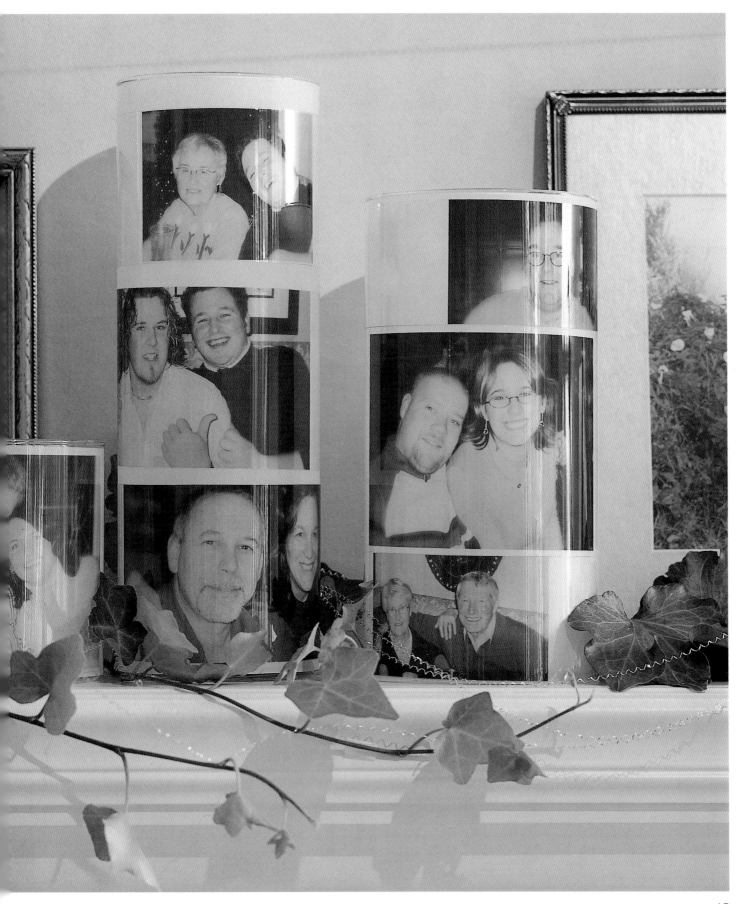

VACATION MOBILE

This modern design mobile is an eye-catching mix of beading, words, and photos. Holiday photographs printed on vellum make a beautiful translucent presentation when displayed in a window. I made this mobile with four photos and five dangles, but you can use more photos and/or dangles if you wish.

SUPPLIES

Decorative Elements:

Armature wire, 14" long

Beading wire

Beads (in colors to match your photographs)

Pearl paper card stock

Photographs – printed on vellum using an inkjet printer

Metal word embellishments

Mini silver eyelets

Other Supplies & Tools:

Crimp beads

Jewelry pliers

Eyelet setting tool

Awl

Hammer

Double-sided tape

Shape cutter and square templates

INSTRUCTIONS

1. Hammer the ends of the armature wire to flatten them. Use the hammer to texture the rest of the piece of wire to give it a forged appearance.
2. Make two small holes in each flattened end of wire piece with an awl. Install an eyelet in each hole.
3. Using a shape cutter and template, crop the photos. Cut two of the photos 3½" square and two of the photos 4" square.
4. Cut four squares of pearl paper card stock to back each of the photographs. Cut the pearl paper just slightly larger all around than the photos so that there will be a slight border around the outside. (Do not attach photos to pearl backing yet.)
5. Determine an area of each of the photos that is the focal point. Measure this area, and cut a small square in each of the pieces of the pearl paper squares to this measurement and in the position where the focal point is.
6. Adhere each of the photos on top of the pearl paper squares with double-sided tape, aligning the focal point of the photo with the cut square.

Assemble:

1. Install eyelets at the top corners of the mounted photographs. Install eyelets in the middle bottom edge or on the bottom corners of some photos. (How many eyelets you need depends on how you plan to assemble the mobile.)
2. Create the beaded word dangles by threading the metal word on a piece of beading wire and securing with a crimp bead. Thread on a selection of beads. Loop the end of the wire through the eyelet on the photograph and use a crimp bead to secure. Repeat with the other words.
3. Assemble the mobile starting with the bottom photo, attaching it to the wire bar with lengths of beading wire and beads. Add the remaining photos, using the project photo as a guide.
4. To add a hanging wire, thread beading wire through the holes on each end of the wire bar and add a small ring at the top. Secure with a crimping bead. ❑

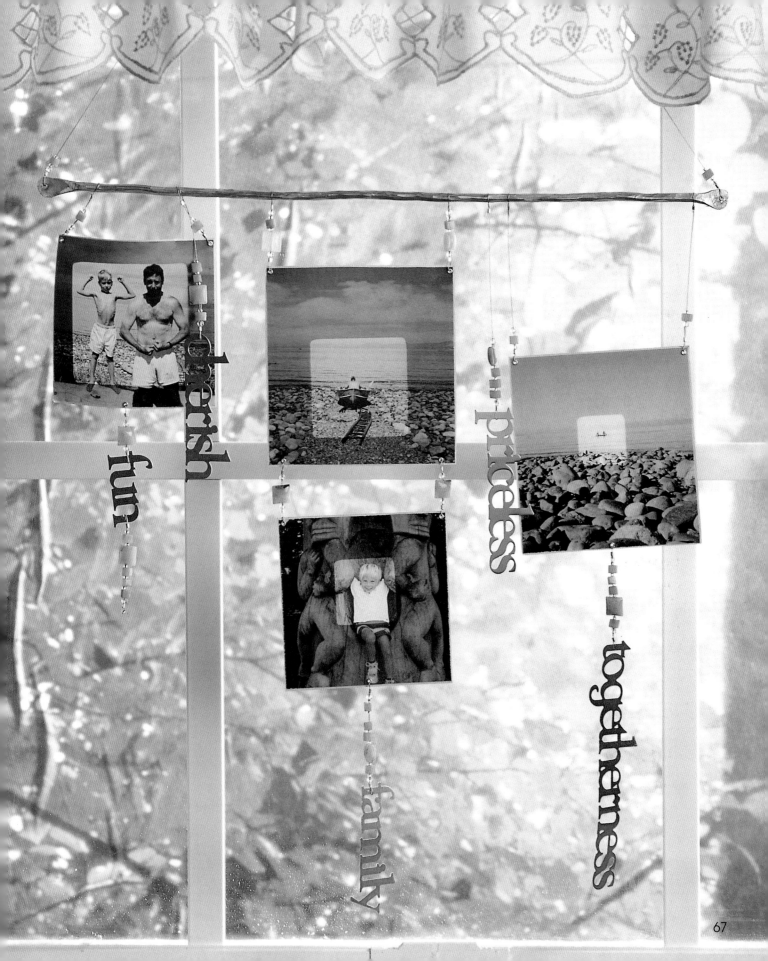

MOD-DOG
PHOTO TOTE

This endearing photo of Brutus was tinted and "posterized" with special effects in a photo-editing program. Some programs even have an "Andy Warhol" effect in the program to instantly make a favorite photo look like a Warhol masterwork. (Using the acrylic tinting technique on black and white photocopies would yield the same result.)

Canvas totes with photo pockets are readily available at crafts stores. I used "orphan" metal letters (various ones in different styles left over from other projects) to spell the dog's name above the photos. I added a polymer clay tag with a photo to one handle. Why not dress conservatively but carry a funky bag!

SUPPLIES

For the Bag:

Canvas tote bag with 12" square pocket for holding photos *or* canvas tote with separate photo pouches

White card stock, 12" square

9 photos, edited and printed with an "Andy Warhol" effect, cropped to 4" square

Metal letters

For the Tag:

Photo transferred to polymer clay

Silver memory frame, 2" x 2"

Chain

Other Supplies & Tools:

Glue stick

Brads

Craft glue

INSTRUCTIONS

Decorate the Bag:

1. Glue the nine photos to the white card stock using the glue stick.
2. Place the photos in the pocket on the front of the tote bag.
3. Embellish the top edge of the tote with metal letters that spell out the dog's name. Glue in place with white craft glue. (I placed brads in the holes of the tag letters before gluing.)

Make the Tag:

1. Transfer a photo to polymer clay using the photo paper transfer technique. See Chapter 6, "Photo Transferring." Trim to fit the memory frame.
2. Bake according to the clay manufacturer's instructions.
3. Place in the frame.
4. Attach to a handle of the bag with the chain. ❏

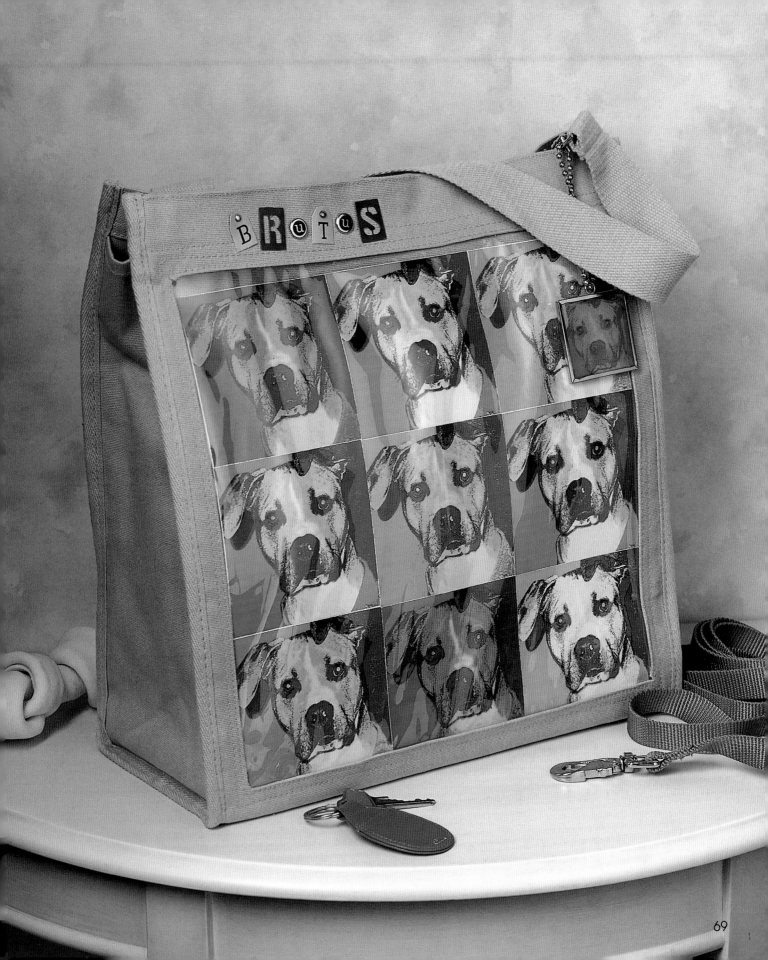

PHOTO
TRANSFERRING

There are many techniques for transferring a photo to a surface. The products and techniques you use depend on the type of surface and the effect you are trying to achieve; different techniques produce different effects. The projects in this chapter include decal transfers, transferring photos to fabric and polymer clay with fabric transfer sheets, and transferring photos to polymer clay with a blender pen.

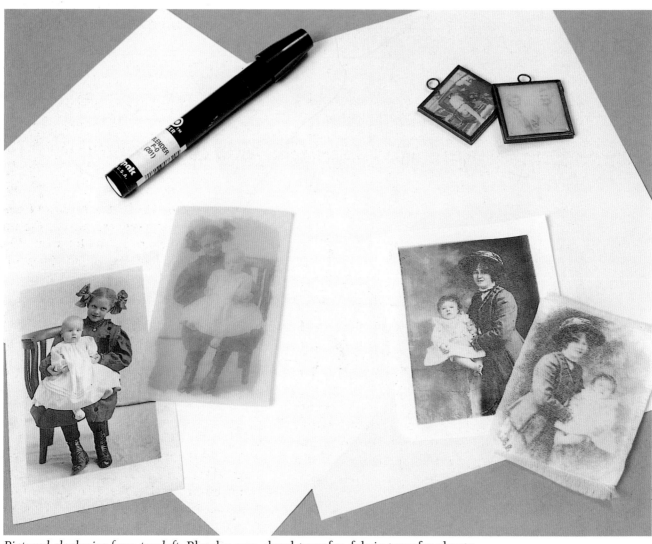

Pictured clockwise from top left: Blender pen, decal transfer, fabric transfer sheets.

Photo Transferring to Fabric

You can print directly on cotton fabric backed with paper or transfer the print with iron-on paper or a blender pen. As some printed fabrics are not washable, the transfer methods, which are washable, are a practical choice for items such as wearables and home decor items like pillows.

Using Iron-on Transfer Paper

Iron-on transfer papers are available for both color photocopiers and inkjet printers at office supply stores. They are reasonably priced and the reproduction is excellent. In this process, the image is transferred to the paper and ironed on the fabric. When the paper backing is peeled away, the image remains. Complete instructions are included. This method requires you to print the image in reverse, especially if there is any lettering in the photo.

Your ironing surface should be hard and smooth; most ironing boards will be fine. Lower the board so you can apply pressure to the transfer while ironing. Different types of fabric give different results; for example, satin gives a smooth, shiny image. Practice and experiment with small images before you start a project.

1. Photocopy or print the photo on the transfer paper according to the manufacturer's instructions. Trim the transferred image leaving a slight ¼" border around the image. You can also use a shape cutter to cut out a decorative shape.

2. Prepare a surface to iron on by placing an old towel onto a hard surface. Your ironing surface should be hard and smooth; most ironing boards will be fine. Lower the board so you can apply pressure to the transfer while ironing. Place the transfer face down on a pre-warmed ironed piece of fabric.

3. Set the iron on the hottest setting with no steam. Apply firm and even pressure to the transfer to fuse it into the fabric, Iron for about 30 seconds. Keep the iron moving at all times to prevent scorching.

4. Peel off the transfer paper while it is still hot to reveal the image. Different types of fabric will give interesting results. For example, satin will give you an image that is smooth and shiny. Practice and experiment with small images before you start a project.

Using Decal Transfer Film

Layering with transparent images adds richness and depth to your photocraft projects. You can apply a photo-printed decal permanently to many different surfaces, including fabric, metal, stone, glass, wood, painted surfaces, and paper. Because the film is thin, it's perfect for textured surfaces such as stretched canvases.

For best results, purchase the correct transfer film – sheets for laser printing (for color photocopiers) or sheets for inkjet printing (that you can print yourself) and follow the film manufacturer's instructions. You do not need to reverse the image for this technique. These transfers work well on white surfaces, as the decal is clear. White areas on the photograph will be clear on the decal film.

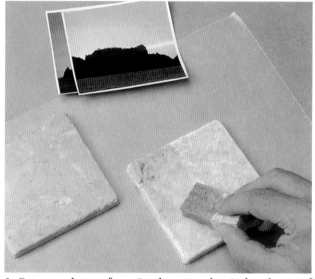

1. Prepare the surface. In this sample, A thin layer of paint thinner was sponged on the surface of a marble tile.

2. Soak the printed transfer sheet in warm water.

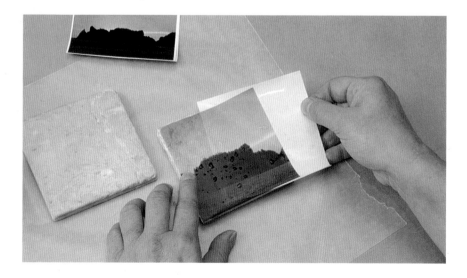

3. Slide the decal off of the backing paper and onto your project surface.

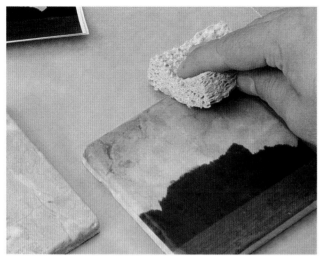

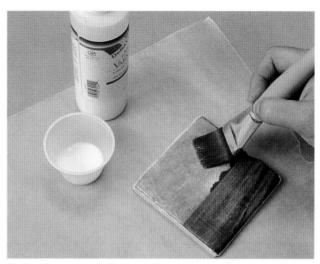

4. Gently sponge the transfer to remove bubbles or wrinkles, and to form over the edge. Be very careful! At this stage the decal film can easily tear. Let dry.

5. Apply a coat of varnish to the surface or prepare for a 2-part polymer coating. Let dry.

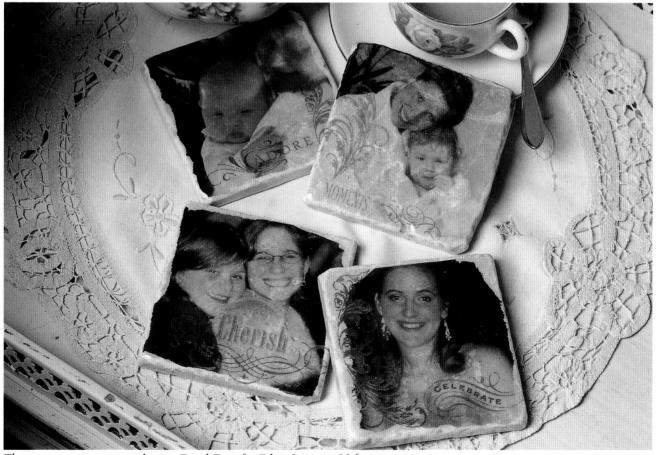

These coasters were created using Decal Transfer Film. See page 80 for instructions.

Transferring to Polymer Clay

You can use fabric transfer paper to print images on polymer clay and create ornaments and jewelry. The technique is simple, but attention to all the steps is important for success. I reduced the photographs to make images 1" to 2" high. You will need to reverse the images for this technique. White polymer clay will give you the sharpest image; you can also use cream, translucent, and/or beige.

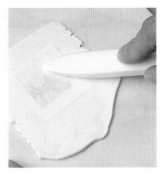

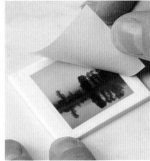

1. Print the image onto fabric transfer paper. Trim the transferred image to the size and shape you wish to transfer. (You can also use templates to cut the image into an oval, a circle, a square, or a star shape.)

2. Condition the clay well and roll out to ¼" to 1/8" thick and at least ½" larger all around than the size of the printed image. The clay should be completely smooth, with no air pockets or indentations.

3. Place the clay on a glazed tile. Place the transfer paper, image side down, on the clay. Using a bone folder or the back of a spoon, rub over the back of the print to press the image into the clay. Go over the paper several times to make sure the image is firm against the clay. This is the most important step, as if the image is not pressed into the clay, it will not transfer completely.

4. Without removing the paper print, use a sharp blade to trim the clay to ¼" to ½" from the paper. If you wish to have holes for threading, make them now with a toothpick.

5. Preheat the oven to the temperature recommended by the clay manufacturer. Place the tile, with the clay and paper on it, in the preheated oven. Bake according to the clay manufacturer's instructions. When the baking is complete, remove from the oven and let cool slightly. Carefully peel off the paper to reveal the image. If there are spots where the image did not adhere, touch up the areas with permanent felt markers.

Blender Pen Transferring

This image transferring technique creates a print with a soft, muted appearance on polymer clay, smooth fabrics, and paper. (The images created on fabric look like antique cigarette silks from the early 1900s.) A photocopied image is transferred with a lacquer-based blender pen, which releases the color toner from a photocopy onto the surface. Familiar to those working in graphic arts, blender pens (sometimes called "blender markers") are available at arts supply stores.

The image must be photocopied on a color copier, even if it is a black and white photograph. Work in a well-ventilated area (blender markers are smelly) and cover your work surface with several sheets of paper for a soft, slightly padded surface.

SUPPLIES

Color photocopy of a photo

A surface – smooth white card stock, white or light-colored polymer clay (conditioned, rolled flat, unbaked), or smooth white fabric

Blender pen

Low-tack masking tape

Spoon *or* bone folder (for burnishing. The spoon cannot be used in food preparation after it is used in this technique.)

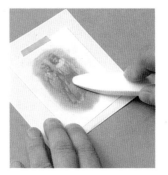
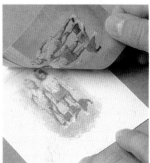

1. *On paper or fabric:* Attach your photocopied image, face down, on the surface to which you want to transfer the image, using a small piece of tape. *On polymer clay:* Roll out the clay and place it on a glazed tile. Place the photocopied image face down on the clay.

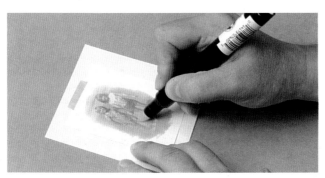

2. Starting in the center of the image, stroke the blender pen across the back of the photocopy. You will be able to see the image quite clearly – the lacquer makes the copy paper transparent. Continue to stroke, moving out to the edges, so the lacquer saturates the entire area you wish to transfer.

3. Immediately use the back of a spoon or a bone folder to burnish the back of the paper over the entire image area. This action helps to release the toner. Carefully peek under a corner to see if the toner has been released; if not, repeat steps 2 and 3.

4. *On paper and fabric:* Remove the photocopied image to reveal the transfer. The image will seem a bit blurry and faded but will improve after drying for about 30 minutes. The excess lacquer will soon evaporate, so don't be too quick to toss out what looks like a failure.

 On polymer clay: Place a second glazed tile on top of the clay and the photocopied image to keep the image pressed firmly against the clay. Bake according to the clay manufacturer's directions. The photocopied paper will fall right off when cool, leaving the image on the surface of the clay.

SAILING DAY CANVAS

Several photographs from a day of sailing make a wonderful souvenir when combined in a collage with letters and stickers and placed in a frame. This project was created with decal transfer film. These stretched canvases are readily available at fine art stores and large craft outlets.

SUPPLIES

Project Base:

Stretched artist's canvas, 12" square

Wooden shadow box frame (to hold a 12" square canvas)

Decorative Elements:

4 to 5 photographs (to fit your theme)

Clear plastic letters, 2" to 3" (to spell words to fit your theme)

Stickers with sayings on clear backing (to match your theme)

Decal transfer film

Other Supplies & Tools:

White acrylic paint

Sandpaper

Acrylic varnish, gloss and matte

Sponge

Craft glue

Hardware for hanging the frame

INSTRUCTIONS

Decorate the Canvas:

1. Prepare the surface of the canvas by applying a coat of varnish. Let dry.
2. Transfer your photos to decal transfer film, using either the color photocopy technique or the inkjet technique. See the beginning of this chapter for details.
3. Following the transfer film manufacturer's instructions, soak the transfer film and slide the transfer onto the surface of the canvas. Cut out the corners and fold the edges over the sides of the canvas.
4. Gently sponge the transfer to remove bubbles or wrinkles. Be very careful! At this stage the decal film can easily tear. Let dry.
5. Apply a coat of gloss varnish to the surface. Let dry.
6. Add the decorative stickers.
7. Brush on a second coat of gloss varnish. While this varnish coat is still wet, place the plastic lettering.

Prepare the Frame:

1. Brush one coat of white acrylic paint on the wooden frame. Let dry.
2. Sand the edges of the frame for a weathered look. Wipe away the sanding dust.
3. Apply a coat of matte varnish. Let dry.

Assemble:

1. Glue the canvas into the frame with white craft glue. Let dry completely.
2. Attach the hardware for hanging. ❑

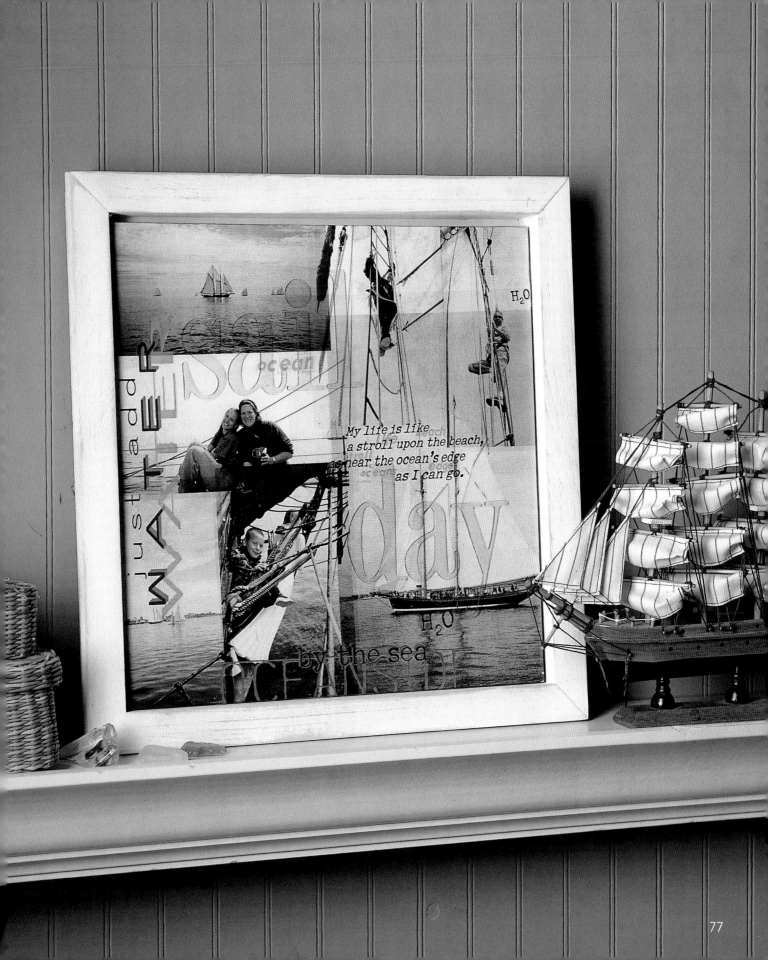

My life is like
a stroll upon the beach,
as near the ocean's edge
as I can go.

just add WATER

by the sea

OCEANSIDE

H₂O

KAYAK
CANVAS GROUPING

Photographs were transferred to three sizes of stretched artist's canvas panels to create this wall grouping. Clear plastic letters spell out "calm" and "serene" and add subtle interest. You can use similar photos in your grouping (as I did with these of Scott in his ocean kayak) or take a single photo and cut it into sections.

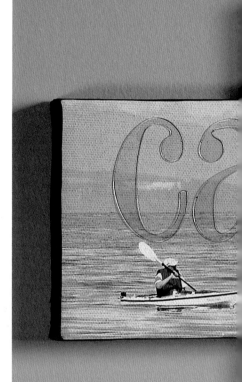

SUPPLIES

Pre-stretched artist's canvas(es)

Favorite photograph(s) (to fit the canvas(es))

Decal transfer film

Acrylic paint (choose a color to accent your photos)

Clear plastic letters, 2" to 3" tall

Acrylic varnish

Paint brushes

Sponge

INSTRUCTIONS

1. Transfer the photos to the decal transfer film using either the color photocopy method or the inkjet method. See the beginning of this chapter for details.
2. Prepare the canvas surfaces by painting them with a coat of varnish. Let dry.
3. Following the transfer film manufacturer's instructions, soak one of the transfer film pieces and slide the transfer onto the surface of one canvas. Cut away the corners and fold the edges over the sides of the canvas.
4. Gently sponge the transfer to remove any bubbles or wrinkles. Be very careful! The decal film can easily tear at this stage. Let dry. Repeat the process with the remaining decal transfer(s) and canvas(es). Let dry.
5. Apply a coat of varnish to the surface of each canvas.
6. Paint the edges of the canvases with acrylic paint.
7. Brush with a second coat of gloss varnish. While this varnish coat is still wet, place the plastic letters on the canvases. Let dry. ❑

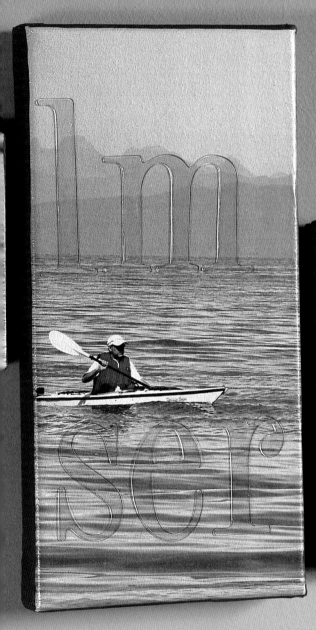

MARBLE PHOTO
COASTERS

Decal transfer film can be applied to stone surfaces like these tumbled marble tiles to make photo coasters. This is without a doubt my favorite photocraft gift to make; the coasters are always appreciated and cherished. They are accented with decorative rub-ons and coated with a two-part polymer coating, which makes the surfaces shiny and waterproof.

The photos were digitally edited with soft focus and spot color. I especially like how the veins and delicate coloring of the marble shows through the transparent transfers. TIP: Make sure you choose marble tiles that do not have too much color when using photographs of people, or substitute plain white tiles for the tumbled marble ones.

SUPPLIES

Project Base:

Tumbled marble tiles, 4" square

Decorative Elements:

Photos

Decal transfer film

Decorative rub-ons

Other Supplies & Tools:

Cork dots, 4 per coaster

Turpentine

Two-part polymer coating and coating supplies

Metal ruler

Soft cloth

Sponge

INSTRUCTIONS

1. Transfer your photographs to decal transfer film, using either the color photocopy method or the inkjet printer method. See the beginning of this chapter.
2. Tear, rather than cut, the images to a size slightly smaller than 4" square.
3. Prepare the surfaces of the tiles by rubbing them with paint thinner or turpentine applied with a soft cloth or sponge.
4. Working one tile at a time and following the transfer film manufacturer's instructions, soak the transfer film and slide the transfer on the surface of the tile.
5. Gently sponge the transfer to remove any bubbles or wrinkles. Be very careful! At this stage, the decal film can easily tear. Let dry.
6. Repeat the process with the remaining decal transfers and tiles. Let dry.
7. Coat the images with two seal coats of white glue. Let dry completely. **Note:** You must seal the decals with glue or the polymer coating will bead on the surface, giving you an unsatisfactory finish.
8. Add the decorative rub-ons to the tiles.
9. Follow the directions for applying the polymer coating. See the beginning of Chapter 7, "Decoupage," for instructions.
10. When cured, add the cork dots to the bottoms of the tiles. ❑

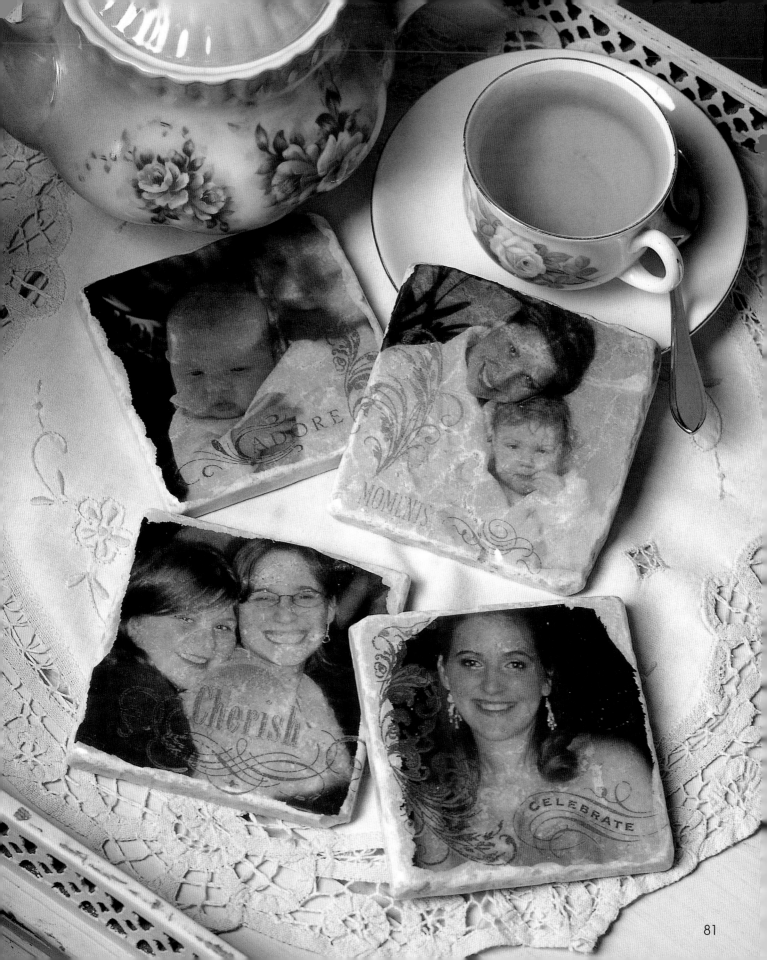

ROSE PURSE

This eyecatching accessory is adorned with a rose photograph and glittery rhinestones. You can use it as a purse or as a tabletop accent to hold garden photographs. If you use a wooden purse blank, basecoat the front with gesso before applying the image.

SUPPLIES

Project Base:

White papier mache purse blank, 8" x 6" x 3½"

Decorative Elements:

Rose photograph enlarged to 8" x 10"

Decal transfer film

Decorative rub-ons – Black paisley designs

Rhinestones, 3mm

Black acrylic paint

Clear crystal beads – six 20mm, twelve 8mm (for the handle); six 8mm, one 20mm, one 45mm teardrop (for the beaded tassel)

Beading wire

Other Supplies & Tools:

Acrylic varnish, matte and gloss

Crimp beads

Craft glue *or* rhinestone applicator tool

Sandpaper, 100 grit

Sponge

Scissors

Needlenose pliers

INSTRUCTIONS

Prepare:

1. Transfer the photo to decal transfer film, using either a color photocopier or an inkjet printer. See the beginning of this chapter for details.
2. Remove the hardware from the purse.
3. Rub the purse surface with sandpaper to dull the surfaces.
4. Prepare the front of the purse by applying a coat of matte varnish. Let dry.

Assemble:

1. Following the manufacturer's instructions, soak the transfer film and slide the transfer onto the prepared front of the purse. Trim and fold ½" over the sides. Clip as needed to neatly fold around the curved edges.
2. Gently sponge the transfer to remove any bubbles or wrinkles. Be very careful! At this stage, the decal film can easily tear. Let dry.
3. Apply a coat of matte varnish to the surface. Let dry.
4. Add the decorative rub-ons to the purse, using the project photo as a guide for placement.
5. Paint the sides and back of the purse with the black acrylic paint.
6. Varnish the painted surface with gloss varnish.
7. Add an additional coat of matte varnish to the front, and an additional coat of gloss varnish to the painted surfaces. Let dry.
8. Reattach the clasp and handle loops.
9. Make a handle with crystal beads and beading wire. Thread crimp beads on the ends, put through the handle loops, and crimp the beads to secure.
10. Make a tassel with the remaining crystal beads and attach to the handle with a crimp bead.
11. Add the rhinestones to the paisley designs with a rhinestone applicator or with tiny drops of white craft glue. ❑

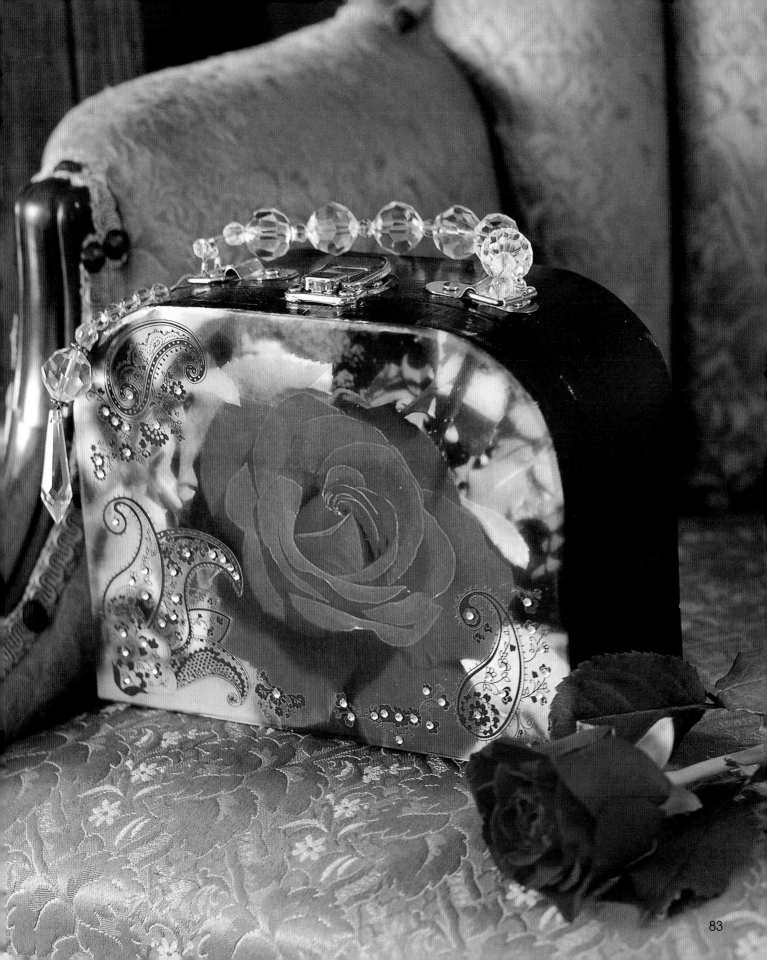

NATURE
PHOTO PILLOWS

These garden photos brighten up plain pillows. The transferred photos are framed with button borders. I used olive green pillows as a base; choose pillow covers that coordinate with your photos or match your decor.

SUPPLIES

Pillow with solid-colored cover, 16" square

Iron-on transfer paper for fabric

Nature photo – 8" x 10" print

Smooth white cotton fabric, 10" square

Rotary cutter, ruler, and cutting mat

35 (approx.) buttons, solid color, 1", ¾", ⅝" diameters

Embroidery thread (to match the pillow cover color)

Tapestry needle

Fine thread and needle

INSTRUCTIONS

1. Transfer the photo to the transfer film, using either the color photocopy method or the inkjet method. See the beginning of this chapter.
2. Crop the image to 8" square.
3. Following the photo transfer manufacturer's instructions, transfer the image to the fabric.
4. Cut the fabric to 8" square. Fold under a ¼" hem on all sides to form a 7½" square panel. Trim the corners to fold neatly.
5. Sew the photo panel to the middle of the pillow with small stitches at the folded edge for an invisible hold.
6. Using embroidery thread, sew the buttons to form a frame around the image. ❏

TIPS

- Use your child's photo for a special grandparent gift.
- A vacation photo will help keep that feeling alive.
- Black and white photos of architectural elements can create a sophisticated designer look.
- Use a photo of a loved one and you can sleep with your head on their shoulder.

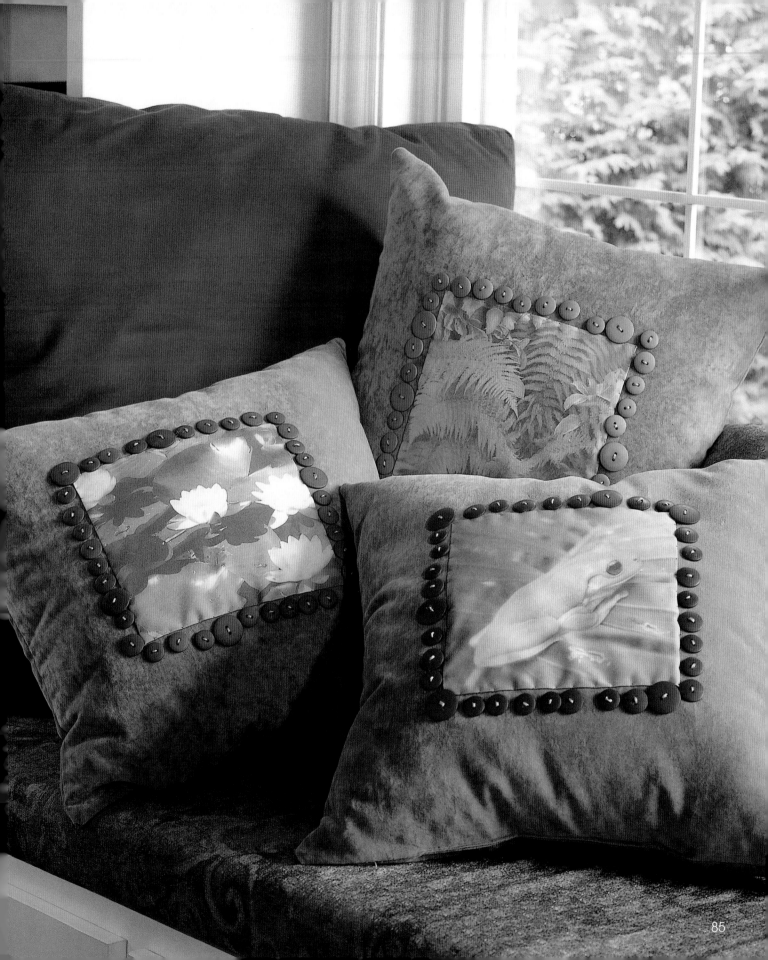

PADDED
PHOTO ALBUM

A padded fabric panel was the perfect accent to adorn this photo album.
You can use the same technique to add a padded panel to larger albums,
photo collages, or other fabric projects.

SUPPLIES

Project Surface:

Wooden album with hinged spine, 6½" square

Decorative Elements:

Photo, 3" x 4"

Smooth white cotton fabric, 5" square

Iron-on transfer paper for fabric

Decorative paper (to coordinate with the photograph)

Blue card stock, cut into 6¼" squares (for album pages)

Mat-weight card stock, 3" square

Stickers – Old keys, locks, keyhole motifs

White label holder

White pearl seed beads, strung on thread

Four small mother-of-pearl buttons

1 yd. dark blue silk ribbon, 1" wide

Other Supplies & Tools:

½" thick polyester batting, 3" square

Double-sided tape

Drill with a ¼" drill bit *or* handheld hole punch

Craft glue

Decoupage medium, matte finish

Decoupage brush

INSTRUCTIONS

Prepare the Photo Panel:

1. Transfer your photo to transfer paper, using either the color photocopy method or inkjet method. See the beginning of this chapter.
2. Following the transfer paper manufacturer's instructions, transfer the image to the fabric. Cut the fabric image to a 4" square.
3. Glue the batting to the mat-weight card stock panel. Let dry.
4. Place the fabric image over the batting. Use double-sided tape to adhere the excess fabric to the back of the mat panel. Fold the corners in first at right angles, and then the sides. Set the padded panel aside.

Prepare the Album:

1. Decoupage decorative paper to the front and back covers of the album. Let dry. Sand the edges flush.
2. Decoupage the insides of the covers of the album with decorative paper, following the same procedure.

Assemble & Embellish:

1. Glue the padded panel to the front of the album with white glue. Place a heavy object, such as a book, on top of the panel while it dries for a strong bond.
2. Embellish the album cover with stickers, using the project photo as a guide.
3. Glue the threaded seed beads around the panel with white glue. Glue the buttons at the corners as shown.
4. Glue the label holder to the album with white glue.
5. Position the pages so they line up with the spine of the album and drill through the pages at the holes in the album cover to make the holes in the pages. *Option:* Use a hand-held paper punch to make the holes.
6. Bind the book by threading the ribbon through the holes, using the photo as a guide. Knot the ribbon to hold the album together. ❑

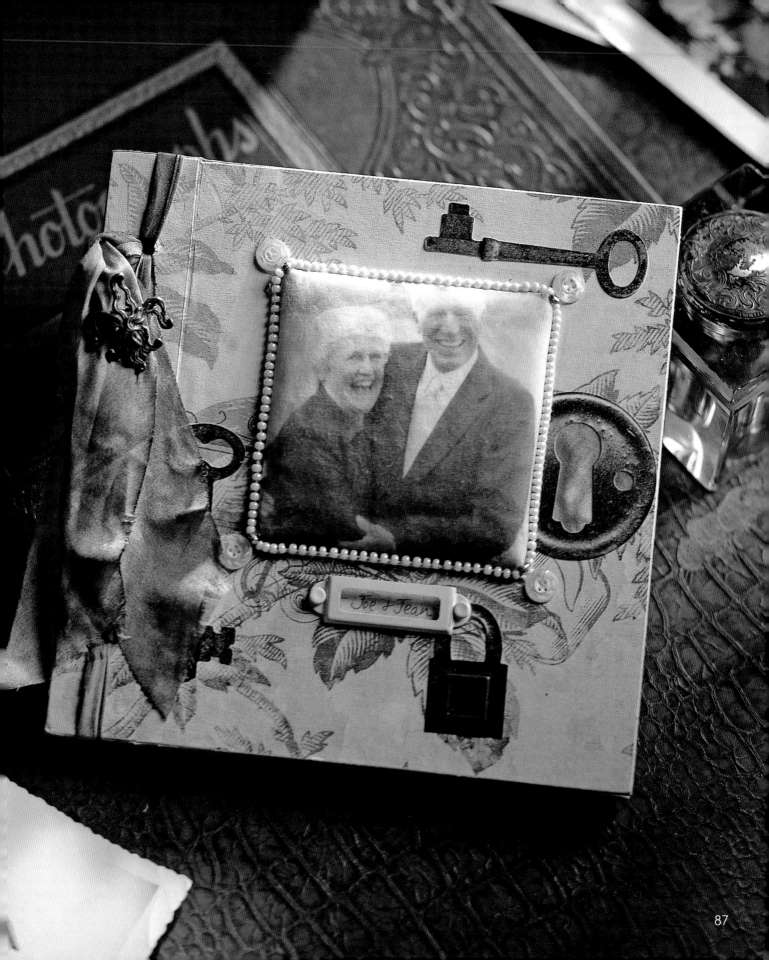

LANDSCAPE NECKLACE

Some scrapbooking embellishments are great for making wearable art, like this photo memory frame. Here it frames a polymer clay piece with a transferred photograph, and it's used as the centerpiece of a beaded necklace. The photo is one my mom took out the window of a train during a trip across Canada. I thought it had an enchanted look and would make a nice memento of the trip. I chose beads in colors that complemented the photo.

SUPPLIES

Decorative Elements:

Photo, reduced and printed on fabric transfer paper

Polymer clay – Translucent, white

Photo transfer tools (See the beginning of this chapter.)

Copper memory frame 1½" square

Beads – dark blue freshwater pearls, silver spacers (variety of sizes and shapes), seed beads (to match photo colors)

Silver clasp

Other Supplies & Tools:

Beading wire

Crimp beads

Polymer clay tools

Beading tools – Crimper, wire cutters

Dimensional varnish, gloss finish

INSTRUCTIONS

Transfer & Frame the Photo:

1. Mix equal amounts of translucent and white polymer clay. Following the instructions at the beginning of this chapter, transfer your image to a 2" square of conditioned polymer clay.
2. Trim the image to 1½" square, using the clay blade. Bake the piece according to the clay manufacturer's instructions.
3. Place the baked polymer clay image in the memory frame. Coat with dimensional varnish. Let dry.

Bead:

The beading is random; use the project photo for beading ideas and follow these basic instructions.

1. Cut two 24" lengths of beading wire. Thread both ends through a pearl bead and then place the bead in the hanger loop of the memory frame. Adjust the beading wires around the loop and make sure the wire lengths are even on each side.
2. Starting on one side, follow this beading sequence: bead 1" with silver spacers on both wires. Next, separate the wires and thread silver spacers, seed beads, and pearls on each strand for 2½". Bring the wires back together and add seed beads, pearls, and silver spacers for 6½".
3. Follow the same sequence to make the other side, forming a necklace 20" long.
4. Use a crimp bead to secure one side of the clasp to each end. ❏

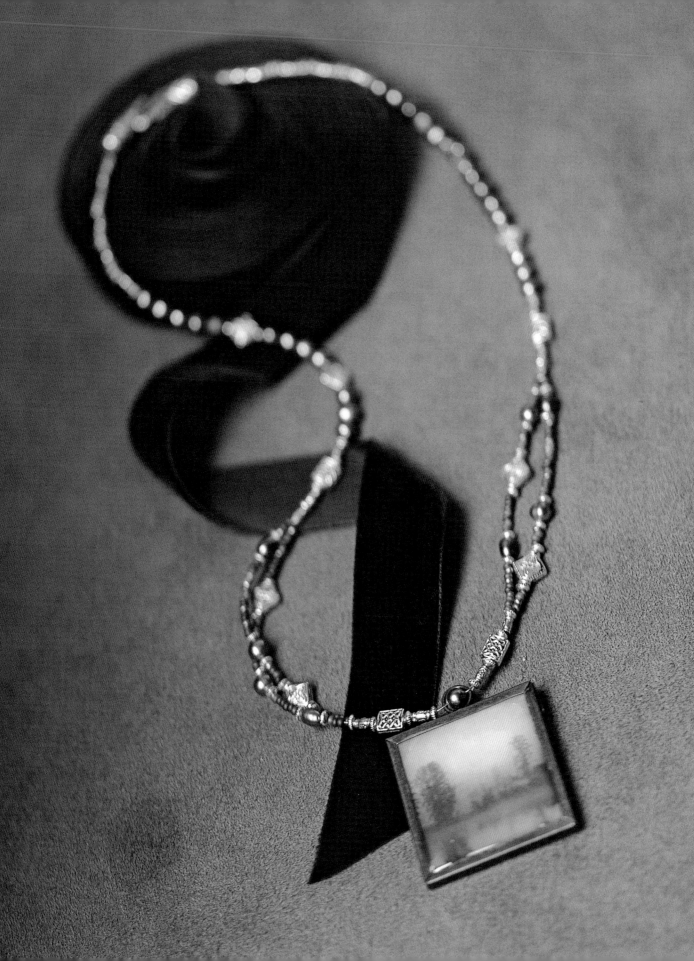

POLYMER CLAY
TAGS

These tags have softly colored images accented with rub-on salutations.
One is 2" x 2¾"; the other is 2" x 2½".

SUPPLIES

For one tag

Color photocopy of photo

Polymer clay – Translucent, white

Polymer clay tools

Blender pen

Blender pen transfer tools

Rub-on salutation and/or designs

Natural jute, 12" length

Eyelet and eyelet setting tools

Plastic straw

INSTRUCTIONS

1. Mix equal amounts of white and translucent polymer clay and condition. Follow the blender pen transfer technique at the beginning of this chapter to transfer the image to the polymer clay.
2. Trim the clay with the clay blade into the tag shape. Use a straw to make a hole at the top of the tag for the eyelet.
3. Bake, following the instructions for the blender pen transfer technique and the clay manufacturer's instructions.
4. Set the eyelet in the hole.
5. Thread and knot the jute to make the hanger.
6. Use rub-ons to accent the tag with a sentiment and/or designs. ❏

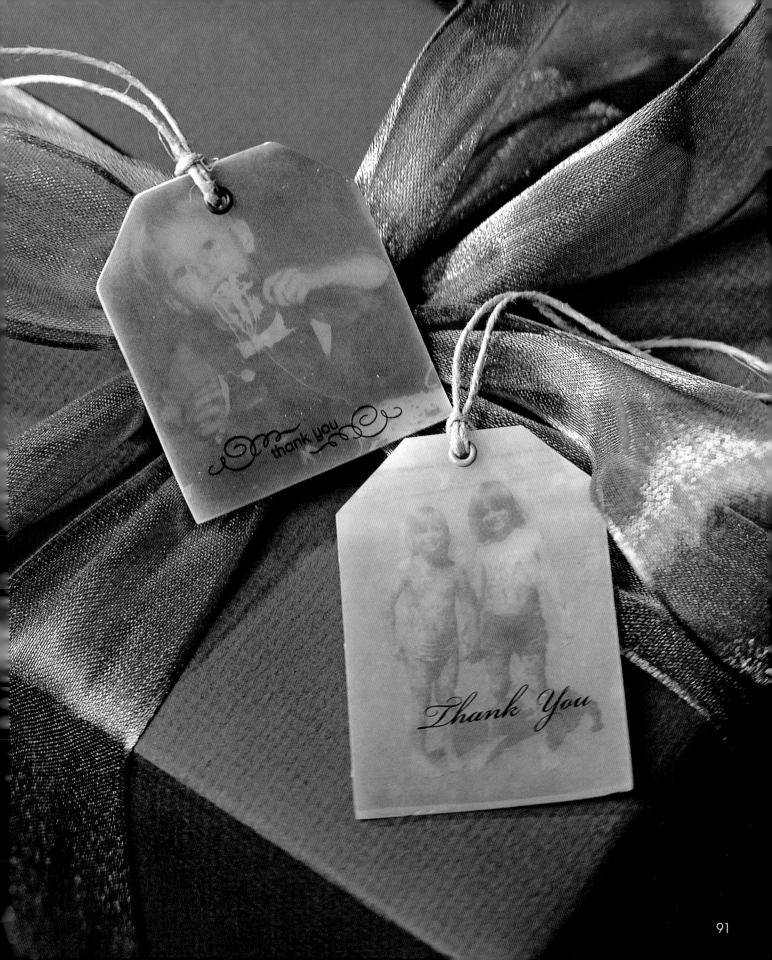

DECOUPAGE

You will need basic decoupage skills for the projects in this chapter. Perfectly trimmed images and careful gluing will result in heirloom quality projects that you will be proud to display and give as gifts. Photographs that have been color photocopied work best for decoupage projects. Some inkjet prints, depending on the paper used, may run and bleed when used with decoupage medium.

Two techniques are shown with step-by-step photos at the beginning of this chapter – traditional decoupage using a podge-type decoupage medium and decoupage using a two-part polymer coating.

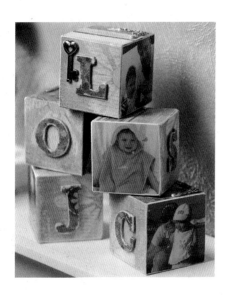
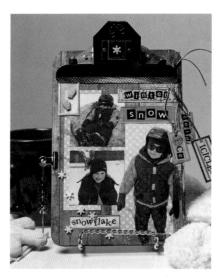
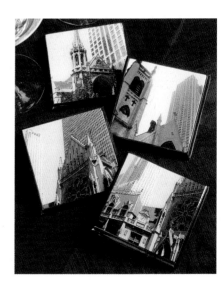

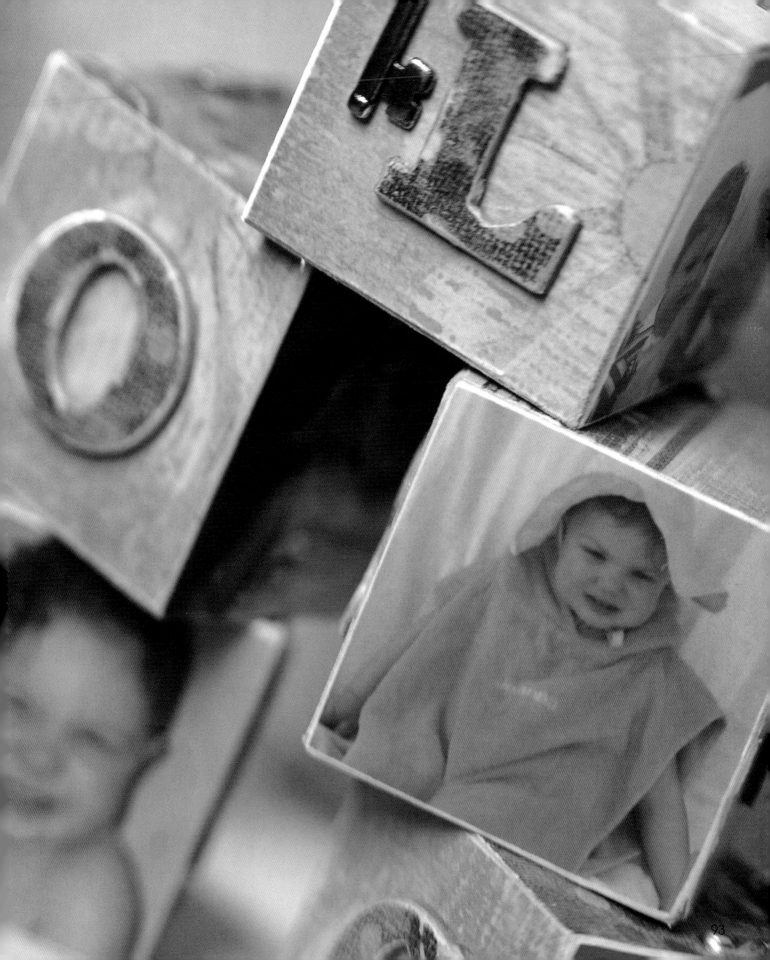

Traditional Decoupage

Decoupage Medium

On wooden items and paper or canvas bases, use decoupage medium to adhere paper pieces. Regular podge-type decoupage mediums come in a variety of finishes including gloss, satin, and matte. Sepia-tone and pearl finishes offer greater design possibilities.

Brushes

Use a ½" to 1" flat brush to apply decoupage medium to the back of the paper.

Scissors

Use sharp craft scissors with pointed blades to cut the outer edges of paper pieces for decoupage.

Art Knife

A scalpel-type art knife or craft knife with a replaceable pointed blade is used to cut away inside areas of paper pieces.

Cutting Mat

A self-healing cutting mat protects your work surface when you work with a craft knife and helps you make accurate cuts. The mat's surface seals itself after each cut so your knife won't follow a previous cut.

Acrylic Varnish

A brush-on acrylic varnish protects decoupaged surfaces. Acrylic varnishes come in gloss, satin, and matte as well as sepia-tinted. The more thin coats you apply, the tougher the surface will be.

To apply: Roll the varnish container instead of shaking it to minimize the appearance of bubbles on your finished piece. Pour the var-

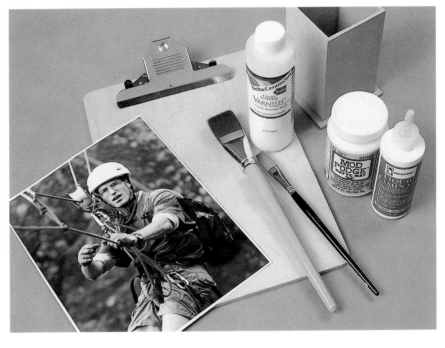

nish in a small disposable bowl (to prevent the large container from being contaminated) and use a large soft brush to apply the varnish to the surface in slow, thin coats. Let each coat dry thoroughly before adding another layer.

To care for a varnished surface: Wipe with a damp cloth. For tough stains or marks, gently sand with very fine sandpaper until the mark is gone. Re-varnish with at least two coats.

Dimensional Varnish

This product comes in a handy bottle with a narrow opening that allows you to squeeze the varnish on individual project pieces. It dries clear and with a slight dimension. Available in clear, sepia, antique hues, and clear crackle, dimensional varnish is a way to create a shiny, dimensional piece without using a polymer coating.

To apply: After the paper piece is adhered to the project, topcoat it with decoupage medium. When dry, squeeze on the dimensional varnish, first outlining the paper piece, then filling in the center, being careful not to let the varnish flow off the piece. Leave undisturbed until dry.

1. Cut Out the Image

Trim away the excess paper from around the image you wish to cut out. Use an art knife and cutting board to cut away inside areas, then use small, sharp, pointed scissors to cut out the images. Hold the scissors at a 45-degree angle to cut the paper with a tiny beveled edge. This edge will help the image fit snugly against the surface. Move the print, not the scissors as you cut. It is much easier to cut images from photocopies rather than cutting a photographic print.

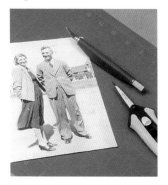

2. Glue to the Surface

Cover your work surface with freezer paper to protect it. Using a 1" wide brush, lightly coat the back of the image with decoupage medium. Position the cutout on the project surface and smooth it with your fingers, pushing out wrinkles and air bubbles. Allow to dry completely before proceeding.

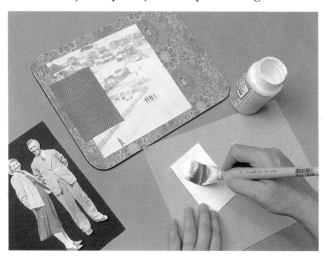

3. Finish

Apply two to three coats of the decoupage medium with the brush. The finish appears cloudy when wet, but will dry crystal clear. If you are planning to coat your project with the pour-on resin, seal the decoupaged surface with two coats of thin-bodied white glue.

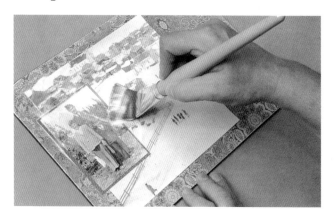

TIP

Use 100-grit sandpaper to create a perfect, flush fit when applying a photograph to a plaque, tray, coaster, or other wooden surface. This method gives a precise, professional-looking edge and requires no guesswork – the image will fit the surface exactly. Cut the image at least ½" larger all around than the surface. With decoupage medium, adhere the image to the surface and let dry completely. Holding the sandpaper at a 45-degree angle to the edge of the surface, sand the edge, being careful not to scratch it, until the sandpaper cuts through the paper.

Using a Two-Part Polymer Coating

A polymer coating is a liquid plastic that can be poured on a variety of surfaces and cures to provide a thick, permanent, waterproof, high-gloss surface. The coating comes in two parts, a resin and a hardener. When equal parts of each are mixed together, they react chemically to form the plastic coating. I use it on many projects for a professional-looking finish and a practical, easy-to-clean surface. The process is easy and the results are spectacular.

Basic Supplies

Photos or photocopies of photos

Two-part pour-on polymer coating

Plastic mixing cups with accurate measurement marks

Wooden stir stick

Disposable glue brush

Freezer paper *or* wax paper

Clear cellophane tape

Sandpaper

Thin-bodied white glue

1. Seal the Project

Prepare the actual or photocopied photos by sealing them with two thin coats of thin-bodied white glue. Allow to dry completely before proceeding. **Note:** If photos or other papers are not sealed properly, the resin will seep underneath and create dark marks.

2. Prepare the Project Surface

When you pour the coating, some of it will drip off the sides of the project. To prevent drips forming on the bottom, cover the bottom edges with clear cellophane tape, applying tape to the underside of the item. Press the tape down firmly. Also remove any hardware.

3. Prepare Your Work Area

For best results, work in a dust-free room with a temperature of 75 to 80 degrees F. and less than 50 percent humidity. Your work surface should be clean, level, and well-protected with wax paper or freezer paper. The item you are coating should be raised about 2" above the work surface to allow the resin to drip freely off the sides. (I use small disposable plastic cups for this; to elevate smaller pieces, such as jewelry, use wooden toothpicks stuck in plastic foam.)

4. Measure

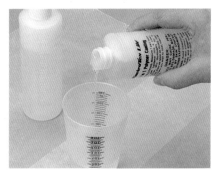

The polymer coating comes in two parts, the resin and the hardener. Disposable plastic cups with measurements printed on the side, which are sold alongside the coating, work best for measuring. Place the cup on a level surface and pour 1 part resin and 1 part hardener in exact amounts by volume into the cup. **Do not** guess or estimate or your coating will turn out soft and sticky. Mix only as much as you can use at one time, as leftover coating cannot be saved for another project. Four ounces of mixed resin will cover one square foot; you must mix a minimum of two ounces.

5. Mix

Mix the resin and hardener vigorously with a wooden stir stick until thoroughly blended – a full two minutes – scraping the sides and bottom of the container continually. The importance of thorough mixing cannot be over-emphasized; poor mixing can result in a soft finish. Do not be concerned if bubbles get whipped into the mixture. Bubbles are a sign that you are mixing properly, and they will be removed after the resin is poured.

6. Pour

Pour right away, do not wait! Pour the coating over the surface of your item in a circular pattern, starting close to the edge and working towards the center. (This allows the resin to level out.) Help spread the coating where necessary with a disposable glue brush. Be careful not to spread the coating too thin or the surface will be wavy. You have approximately 25 minutes of working time before the coating starts to set up.

7. De-Gas

Within 10 minutes of pouring, air bubbles created by mixing will rise to the surface and begin to break. Gently exhaling (not blowing) across the surface will break the bubbles. On large surfaces, you can use a small propane torch to remove air bubbles. The resin contains no flammable solvents, and the carbon dioxide-rich exhaust gases from a propane flame effectively release the bubbles. Hold the torch at least 3 to 4 inches from the surface. Remember it is the carbon dioxide, not the heat that removes the bubbles.

8. Wipe Drips

About 30 minutes after pouring, wipe away any drips from the bottom of the project with a glue brush. Repeat in another 30 minutes to minimize accumulation of the coating along the bottom edge.

9. Allow to Cure

Allow the coated item to cure in a warm, dust-free room that is closed to pets and children for a full 72 hours before using or displaying. (The coating will feel dry to the touch in about 12 hours but isn't fully cured for 72 hours.) Discard the mixing cup, the stir stick, and the brush to clean up.

10. Remove the Tape

Remove any tape from the bottom edge of your item, and the drips will pop off. In an area that wasn't taped, you can remove unwanted drips by sanding. A circular sanding attachment on a hand drill works well.

Continued on page 98

Two-Part Polymer Coating, continued from page 97

Caring for a Resin Finish

- Furniture polish or carnauba car wax prolongs the life of polymer coated surfaces and helps decrease smudges and fingerprints. Use a rag to apply a thin coat of polish or wax, let dry, and buff the piece briskly with a clean, soft cloth.

- Heavy items placed on the surface for long periods of time may leave a slight impression. Once the object is removed, the impression will disappear in a few hours.

- After the coating has cured, it is chemically inert and completely machineable, so you can easily drill or sand it.

When I give handmade gifts that have been coated, I send along a care card. Here is a sample care card for a set of coasters:

CARE CARD

These coasters are heat resistant, waterproof, and alcohol proof. Clean them with a soft damp cloth. Carnauba car polish will prolong the life of the surface and clean away smudges and fingerprints. Objects left on the surface for a period of time may leave impressions. They will disappear in a few hours at normal room temperature.

STACKED
BOOK BOXES

Paper covered stacked boxes with accordion-folded books inside are an interesting alternative to a photo album. Each box holds two or three accordion books. I color photocopied the photos so the books can take lots of handling. The pages were cut from card stock; just add extra panels to make longer books with more pages. Choose papers to decorate the boxes that coordinate with your room decor.

SUPPLIES

Project Surfaces:

3 papier mache stacking boxes with lids

Mat board (for book covers)

Card stock in solid colors (for book pages)

Decorative Elements:

Decorative paper (I used a book of 6" x 6" coordinating papers.)

Photocopies of photographs

Embellishments – 3D stickers, printed ribbon and ribbon buckle, letter charms, paper clips, buttons

Other Supplies & Tools:

Decoupage medium, matte finish

Brush

Glue stick

Instructions continue on page 104

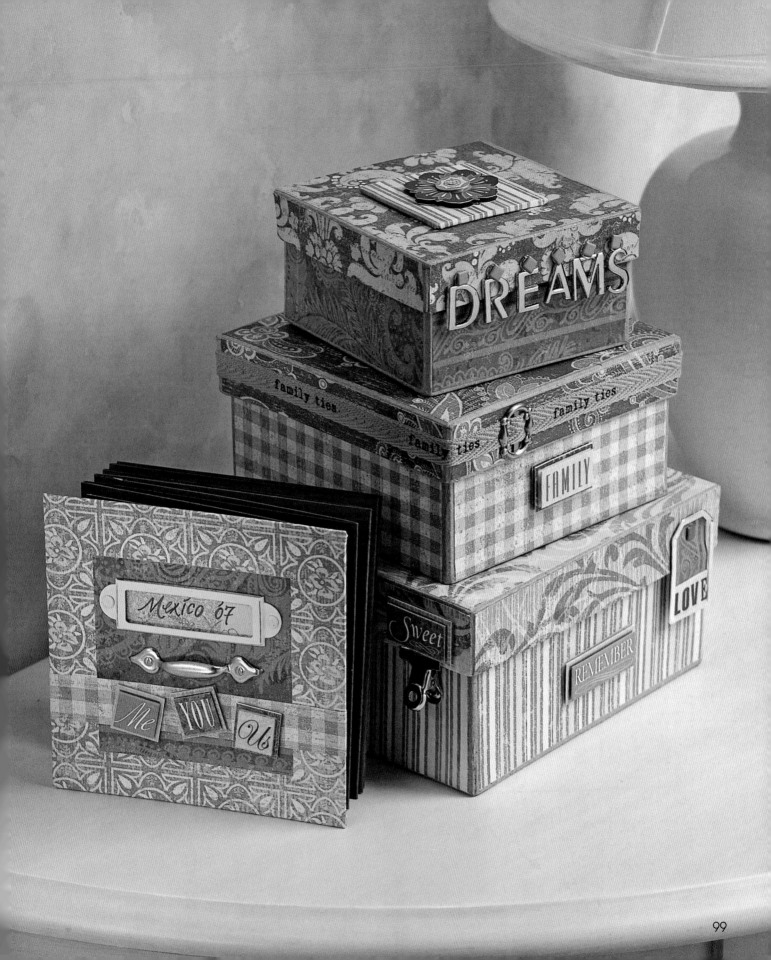

Stacked book boxes, continued from page 98

INSTRUCTIONS FOR COVERING THE BOXES

1. Measure and cut panels from the decorative paper to fit the outside panels of each box and lid. Cut the paper pieces slightly smaller than the panels so a little of the brown papier mache shows.
2. Glue the outside paper panels to the boxes with decoupage medium. Let dry.
3. Apply a coat of decoupage medium to the entire outside of each box and lid and let dry.
4. Decorate the boxes with embellishments, using the photo as a guide. ❑

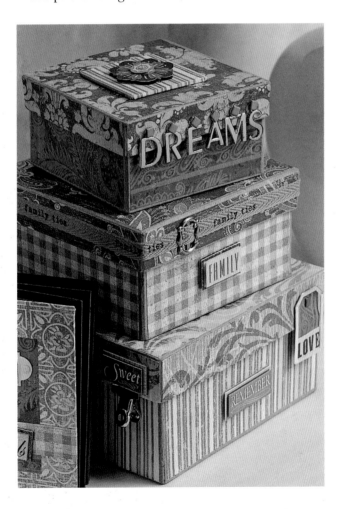

INSTRUCTIONS FOR MAKING THE BOOKS

Cut and organize the parts for each book, listed below according to the size of the box, then assemble.

Cut & Organize for the Large Box:

The box is 6" square.

1. Cut two mat board covers, each 5½" square, per book.
2. Cut two pieces of decorative paper, each 6½" square, for covering the covers.
3. For the pages, cut two sheets of 12" x 12" card paper into four panels, each 5¼ x 10½". Adhere together, with a ½" overlap, using double-sided tape to make a panel 47" long. Accordion fold into 5¼" square panels, folding first at the seams.
4. Trim off the remaining ½". You now have eight pages for your book.
5. Crop the photos to 5" square.

Cut & Organize for the Medium Box:

The box is 5" square.

1. Cut two mat board covers, each 4½" square, per book.
2. Cut two pieces of decorative paper, each 5½" square, for covering the covers.
3. For the pages, cut two sheets of 8½" x 10" card paper into four panels, each 4¼" x 9". Adhere together, with a ½" overlap, using double-sided tape to make a panel 35" long. Accordion fold the panel into 4¼" square panels, folding first at the seams.
4. Trim off the remaining ½". You now have eight pages for your book.
5. Crop the photos to 4" square.

Cut & Organize for the Small Box:

The box is 4" square.

1. Cut two mat board covers, each 3½" square, per book.
2. Cut two pieces of decorative paper, each 4½" square, for covering the covers.
3. For the pages, cut one sheet of 12" x 12" card paper into three panels, each 3¼" x 10¼". Adhere together, with a ½" overlap, using double-sided tape to make a panel 29" long. Accordion fold the panel into 3¼" square panels, folding first at the seams.

4. Trim off the remaining ½". You now have nine pages for your book.

5. Crop the photos to 3" square.

Assemble:

These basic instructions are the same for all the books, regardless of size.

1. Using a glue stick, glue the decorative paper panels to the mat board covers. Fold over the corners, and then the excess paper on the sides to the back, using the glue stick to hold.

2. Glue the pages to the front and back covers with the glue stick.

3. Attach the cropped photos to the pages with a glue stick.

4. Decorate the fronts of the books with the embellishments. ❏

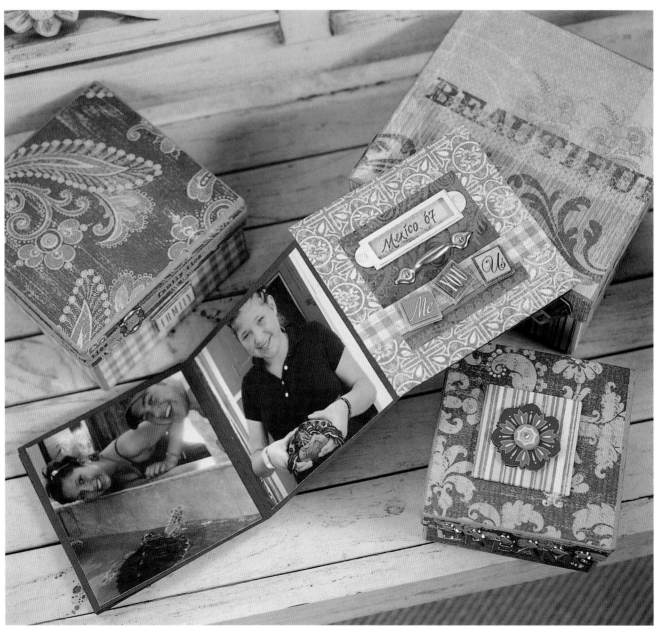

CHICAGO PHOTO COASTERS

Small wooden plaques make wonderful coasters that commemorate a special event such as a vacation, wedding, or holiday celebration. The contrast between the old and new architecture in downtown Chicago inspired this project. The black and white photos were printed on high gloss photo paper with an inkjet printer. Because of their high gloss finish, the photos did not require a glue seal coat before the polymer coating was applied.

SUPPLIES

4 wooden plaques, 4" square

4 photographs, 4" x 6", printed on high gloss photo paper, cropped to 4" square

Black acrylic paint

Paint brush

Two-part polymer coating and coating supplies (See the beginning of this chapter.)

Cork buttons, 4 per coaster

White glue

INSTRUCTIONS

1. Basecoat the edges and the backs of the plaques with black paint. Let dry.
2. With white glue, adhere the photos to the tops of the plaques. Let dry.
3. Apply the two-part polymer coating, following the instructions at the beginning of this chapter.
4. When fully dry and cured, adhere four cork buttons to the bottom of each coaster. ❏

CARE CARD

These coasters are heat resistant, waterproof, and alcohol proof. Clean them with a soft damp cloth. Carnauba car polish will prolong the life of the surface and clean away smudges and fingerprints. Objects left on the surface for a period of time may leave impressions. They will disappear in a few hours at normal room temperature.

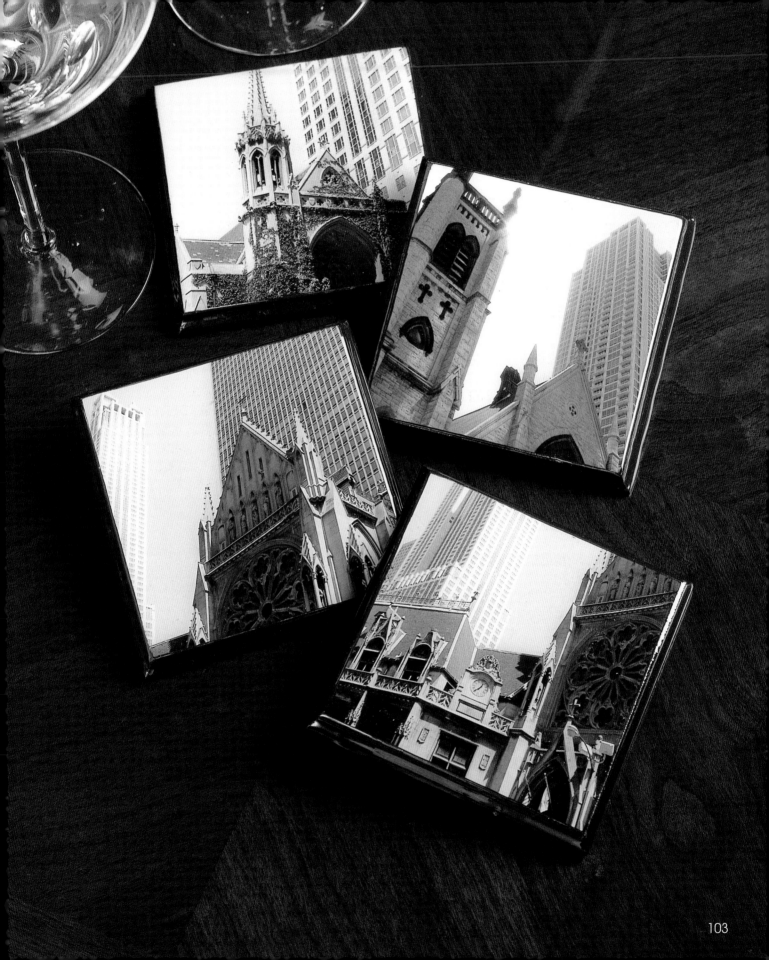

WEDDING PLATES

Square plates are a great surface on which to create memorable display pieces. Here, colorful photos from Michelle and Cory's wedding were paired with decorative paper in the same color tones as their clothing and the decor. A close-up of Michelle's painted hands is the ideal choice for a smaller companion plate.

SUPPLIES

Project Surfaces:

2 white square plates, one 10", one 8"

Decorative Elements:

Color photocopies of photos, one 8" x 10", one 5" x 7"

Decorative papers, coordinating pattern and solid

Metallic gold acrylic paint

Rub-on letters in metallic gold

Other Supplies & Tools:

Two-part polymer coating and coating supplies (See the beginning of this chapter.)

Decoupage medium

Sponge brush

INSTRUCTIONS

Prepare Papers for the 10" Plate:

1. Crop the 8" x 10" photo to a 7" square.
2. Cut an 11" square of patterned decorative paper.
3. Cut a 7½" square of solid-color decorative paper.

Prepare Papers for the 8" Plate:

1. Crop the 5" x 7" photo to 5" square.
2. Cut a 9" square of patterned decorative paper.
3. Cut a 5½" square of solid-color decorative paper.

Adhere the Papers:

1. With scissors, cut a 2" slit toward the center in each corner of the two patterned paper pieces. (This allows the paper to overlap slightly and fit snugly in the recessed part of the plate.)
2. With decoupage medium, glue the patterned paper pieces to the plates. Let dry. Sand the edges of the papers flush to the edges of the plates.
3. With decoupage medium, glue the solid-color panels to the centers of the plates.
4. Glue the photos to the centers of the plates over the solid-color paper panels.

Embellish:

1. Using the sponge brush with gold paint, brush a gold border on the edges of the rims of the plates.
2. Brush the entire surfaces of both plates with two coats of white glue to seal the paper. Let dry until completely clear.
3. With the rub-on letters, add names, dates, or other journaling to the plates.
4. Apply a two-part polymer coating. See the instructions at the beginning of this chapter. ❑

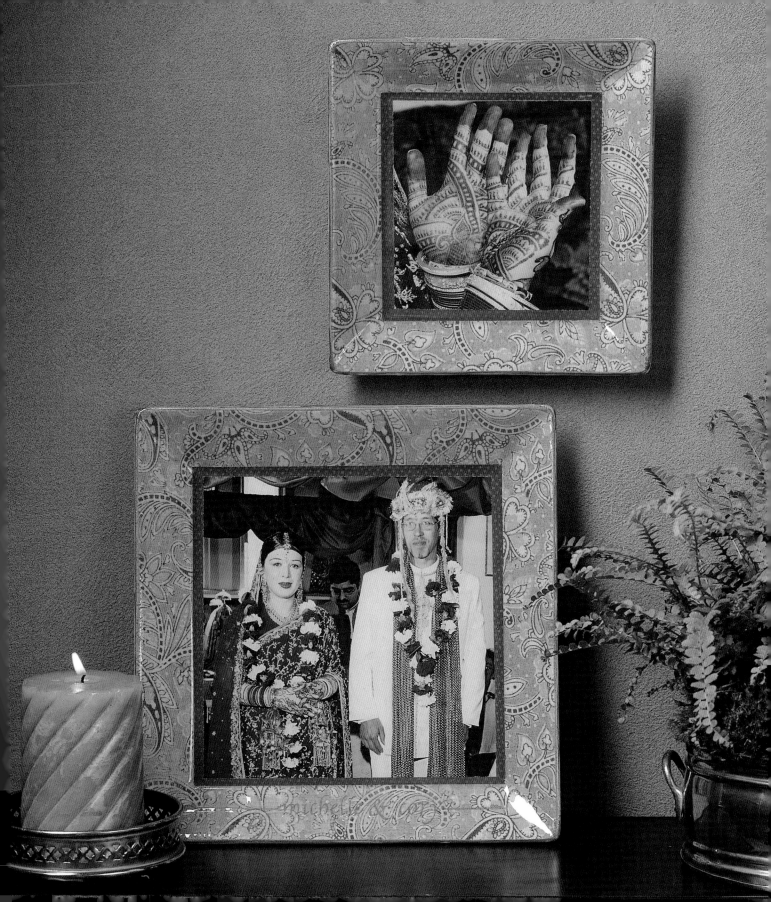

GREEK VACATION
TILE TRAY

This photo collage of Kim's trip to Greece, finished with a polymer coating, has a practical surface that can easily be cleaned. I used a tile mosaic technique to make the collage – I color photocopied the photos, cropped them into different-sized rectangles and squares, and glued them on "tiles" cut from foam core board.

To make a mosaic photo collage, choose photos with the same color theme or subject matter and try arranging the pieces in various ways to compose an interesting design. Fill in any gaps with "tiles" covered with paper pieces in coordinating colors.

SUPPLIES

Project Surface:
Wooden tray, 11" x 15"

Decorative Elements:
Color-photocopied photos
Colored card stock in a coordinating color
Texture paint and palette knife
White acrylic paint
White foam core board, 3/16" thick

Other Supplies & Tools:
Acrylic varnish, matte finish
Paint brush
Art knife, ruler, and cutting mat
Bone folder
Two part pour-on polymer coating and coating supplies (See the beginning of this chapter.)

INSTRUCTIONS

Prepare:
1. Prepare the tray by applying texture paint to the outside surfaces with a palette knife. Let dry.
2. Basecoat the textured surfaces with white paint.
3. Crop the copied photographs and colored paper into squares or rectangles to fit the bottom of the tray.
4. Try different arrangements of photos until the collage pleases you.

Assemble:
1. Using the cropped photos and paper pieces as patterns, cut pieces of foam core board exactly the same sizes to make the "tiles" by placing the cut print piece on the foam core board, lining it up on one side with the edge. Place the ruler where you want to cut and hold it down firmly with your non-cutting hand. Cut the board using firm, shallow strokes. You may need to make two to three passes with the knife to cut through to the mat. Reposition the ruler and make the second cut. Keep the cutout foam core pieces and corresponding photos together.
2. Use thin-bodied glue and a glue brush to spread an even coat of glue on the bottom of each foam core tile. Glue in place in the bottom of the tray. Let glue dry completely before proceeding.

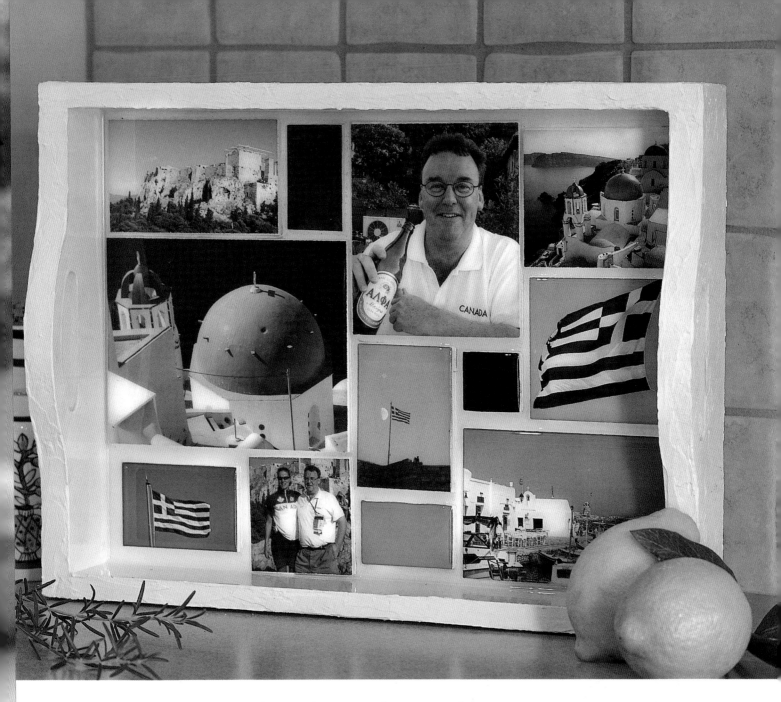

3. Paint the tops and sides of all the foam core tiles and the surface of the tray with two coats of white acrylic paint, leaving no paint puddles between the tiles. Let the paint dry completely before proceeding. (The paint color you choose for this step will be the "grout" color of your tile mosaic.)

4. Working one tile at a time, brush an even coat of thin-bodied glue on the top of the tile and glue the corresponding photo in place. Remove large bubbles and prevent wrinkles by rubbing the edge of a bone folder across the print from the center to the edge.

Finish:

1. Use a glue brush to coat the tops and sides of the tiles and the grout lines with two thin coats of thin-bodied white glue. Pay close attention to the areas where the paper pieces meet the edges of the tiles and the sides of the tiles. Let the first coat of glue dry clear before adding the second coat. Let the glue dry completely clear before proceeding.

2. Apply the polymer coating, following the instructions at the beginning of this chapter. Brush the excess coating up the inside edges of the tray but not over the tray edge. ❑

FAMILY
PHOTO BLOCKS

A set of wooden blocks becomes an engaging photo gallery with hand-tinted photocopies and decorative papers. The black-and-white photocopied photos were adhered with decoupage medium, then tinted with acrylic paints. The decorative embellishments provide dates, initials, and other information. If you are unable to find large wooden blocks, have your local hardware store cut some from fence posts.

SUPPLIES

Project Surface:

3 wooden blocks, 4", 5" and 6"

Decorative Elements:

Dark brown acrylic paint

Color photocopies of photos

Coordinating decorative paper

Embellishments – Metal number charms, metal stencil letters, ¾" wooden tiles

Other Supplies & Tools:

Decoupage medium

Acrylic varnish, matte finish

Craft glue

Brushes

INSTRUCTIONS

1. Basecoat all sides of the blocks with dark brown acrylic paint. Let dry.
2. Cut the decorative paper into panels to fit four sides of each block, making the panels ¼" smaller than the size of the block face. (This will create a thin brown border on each edge.)
3. Decoupage the paper panels to the top, bottom, and two opposite sides of the blocks.
4. Crop the photographs ¼" smaller than the block size. Decoupage to the two remaining sides of each block.
5. Brush one coat of matte varnish over the photos. Let dry.
6. Tint the photos using the acrylic paint technique. See "Tinting Photos with Acrylic Paint" in Chapter 5.
7. Cut 1" square pieces of decorative paper. Cut them in half diagonally to make triangular photo corners. Decoupage the photo corners on the corners of the photographs. Let dry.
8. Brush on two to three coats of matte varnish on all sides of the blocks. Let dry between coats. Let the final coat dry completely.
9. Glue the metal embellishments to the blocks, using the photo as a guide.
10. Cover the tiles with pieces of decorative paper. Coat with varnish. Glue to the blocks. ❏

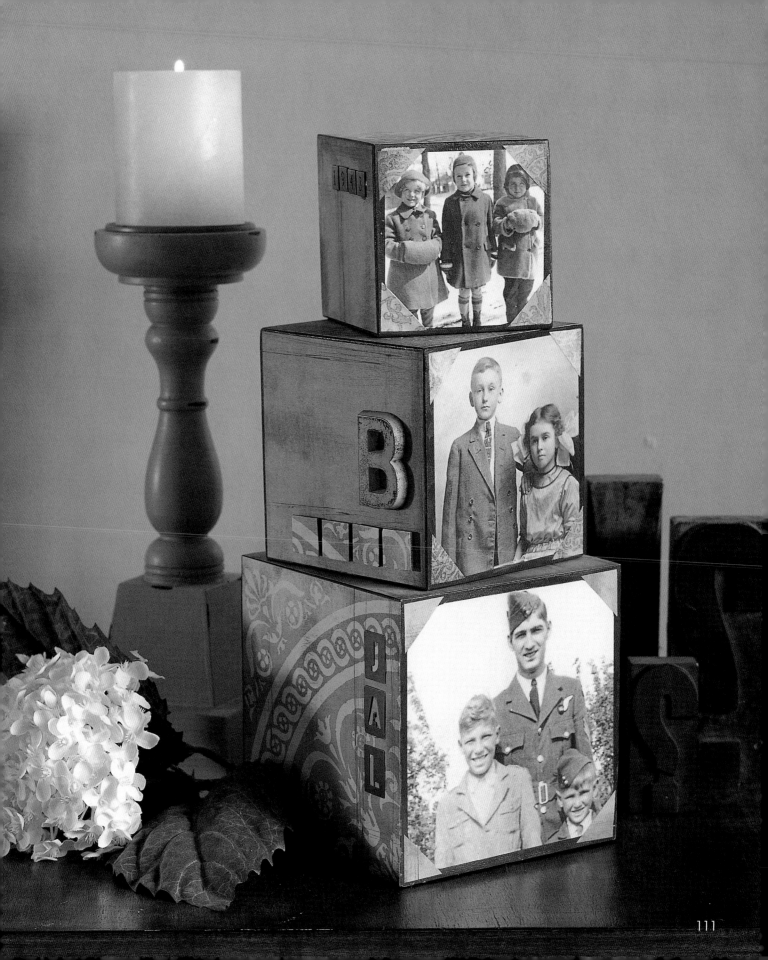

HAND MIRRORS

The vintage baby photo inspired these fun, personalized mirrors. I created two different versions – a fun girl's mirror and the more elegant vintage one. They make unique gifts and are a novel way to accent a dresser. A polymer coating helps hold the charms and buttons in place with no fear of their falling off.

SUPPLIES

Project Surfaces:

Plain hand mirrors (plastic or wood)

Decorative Elements:

For the Vintage Mirror

Color photocopy of a vintage photo, cropped to fit the size and shape of the mirror

Gold metal charms

Plastic leaf and flower beads in clear colors

12" lengths of color-coordinated ribbons and trims

For the Girl's Mirror

Color photocopy of a color photo, cropped to fit the size and shape of the mirror

Plastic novelty buttons and charms

Acrylic rhinestones

12" lengths of color-coordinated ribbons and trims

Silk flowers

Other Supplies & Tools:

Decoupage medium

Brush

White jewelry glue

Two-part polymer coating and coating supplies (See the beginning of this chapter.)

INSTRUCTIONS

1. Decoupage the photo to the back of the mirror.
2. Seal the photo with two coats of thin-bodied white glue.
3. With jewelry glue, adhere the decorative charms and buttons around the photo and down the handle. Let dry completely.
4. Following the instructions at the beginning of this chapter, apply the two-part polymer coating to the back of the mirror and over the glued-on embellishments.
5. When cured, loop the ribbon and trim pieces through the handle. To finish, glue a charm or silk flower on top as shown. ❏

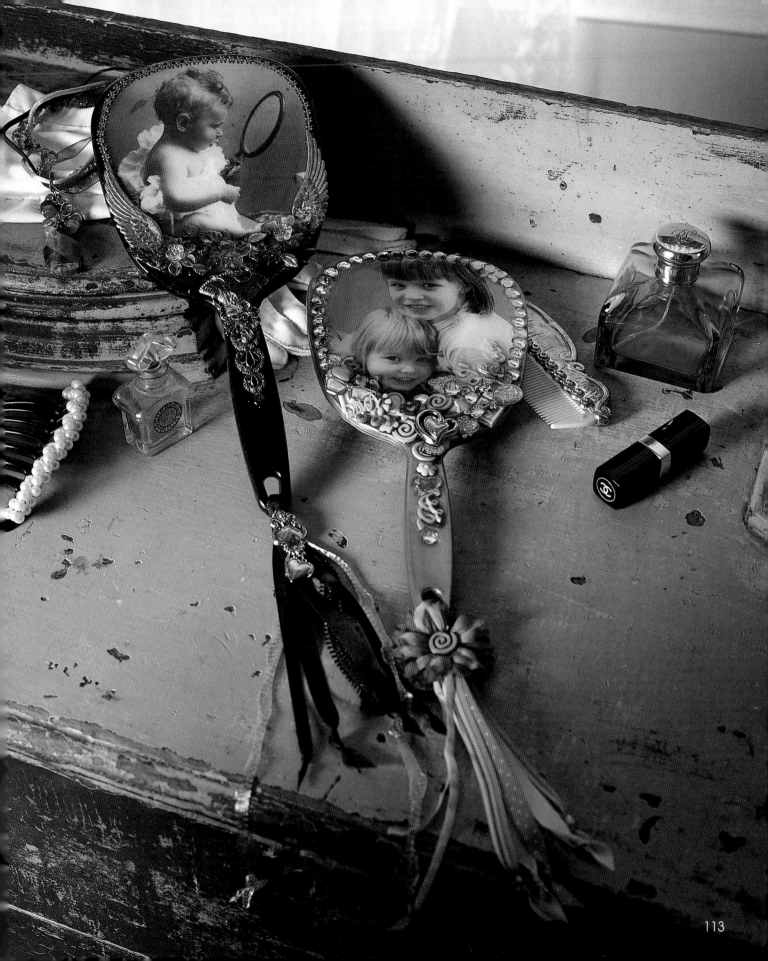

WINTER DAY CLIPBOARD

Clipboards are a wonderful surface for creating a photo collage, and they can be displayed on a shelf or hung on a wall. You can find plain clipboards designed for photocrafting at your local crafts store. The theme can be any cherished moment, such as this fun day in the snow for Hayden and Conner. Choose decorative papers and embellishments to match your theme.

SUPPLIES

Project Surface:

Wooden clipboard, 6" x 9"

Decorative Elements:

Three photos, one printed on transparent paper

Decorative papers

Embellishments – Stickers, novelty charms, tags, label holder

Other Supplies & Tools:

Dimensional varnish, gloss finish

Sandpaper, 100 grit

Decoupage medium, matte finish

Brush

Craft glue

INSTRUCTIONS

1. Remove the hardware from the clipboard and set aside.
2. Use decoupage medium to cover the entire top of the clipboard with decorative paper. Let dry. Sand the edges flush.
3. Arrange decorative paper panels and the photographs on the clipboard and adhere with decoupage medium. Let dry completely.
4. Reattach the hardware to the board.
5. Glue and attach the embellishments.
6. Glue the label holder to the metal clip over a piece of paper. Coat with dimensional gloss varnish. ❏

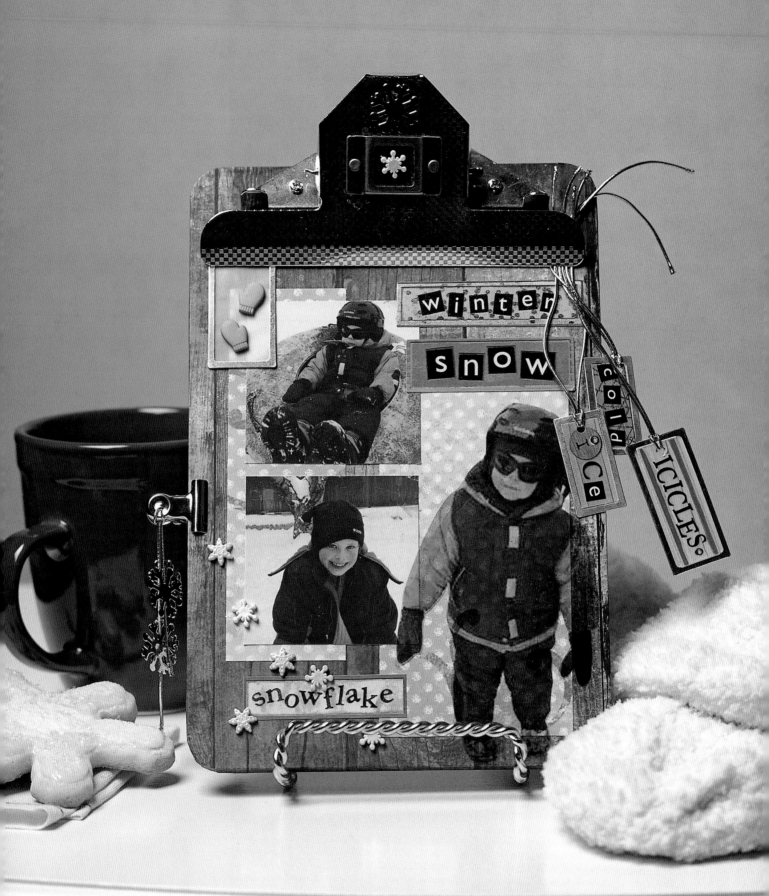

M IS FOR
MASTERPIECE

An oversized papier mache letter was covered with decorative paper and stickers to make a fun gallery for family photos. I chose the letter "M" for my "masterpiece" family. You could use any single letter or spell out a word as a great room accent. This "Masterpiece Gallery" can be displayed on a table or shelf or hung on a wall.

SUPPLIES

Project Base:

Papier mache letter, 12" x 9" x 1½"

Decorative Elements:

Photos – one 2½" x 3½", plus smaller photos to fit the mini frames

Mini photo frames, 1½"

Decorative paper (Choose one with a small pattern or design.)

Acrylic paint (Choose a color that coordinates with the decorative paper.)

Ribbons in coordinating colors, 3½" lengths

Bendable wooden mannequin, 4" tall, stained brown

Stickers – large flowers, *Mona Lisa*, alphabet letters

Embellishments – Chipboard filigree, charms to match theme

Other Supplies & Tools:

Sandpaper, 100 grit

Decoupage medium, matte finish

Brush

Dimensional varnish, gloss finish

Craft glue

Sponge

Glue dots

INSTRUCTIONS

1. To cover the front and sides of the large letter with decorative paper, place the letter on the sheet of paper and trace around it with a pencil to outline a pattern.
2. Cut out the paper and adhere to the letter with decoupage medium. Use sandpaper to sand the edges flush.
3. Add the large flower and Mona Lisa stickers to the letter, folding them over the edges to decorate all sides. Attach the alphabet letters to spell out "Masterpiece." Use the photo as a guide for placement.
4. Sponge acrylic paint on the edges of the letter to help frame the composition. Basecoat the chipboard filigree piece with the same color.
5. Crop the photos to fit the mini frames.
6. Decoupage the photos in place on the front of the letter. Let dry. Glue the mini frames in place over the photos.
7. Coat each photograph and the painted chipboard filigree piece with dimensional varnish. Let dry.
8. Glue the filigree piece in place on the letter with the white craft glue.
9. Turn over the letter and glue the pieces of ribbon to the back.
10. Glue the charms and the mannequin to the top of the letter.
11. Attach the largest photo to the hands of the mannequin with glue dots. ❑

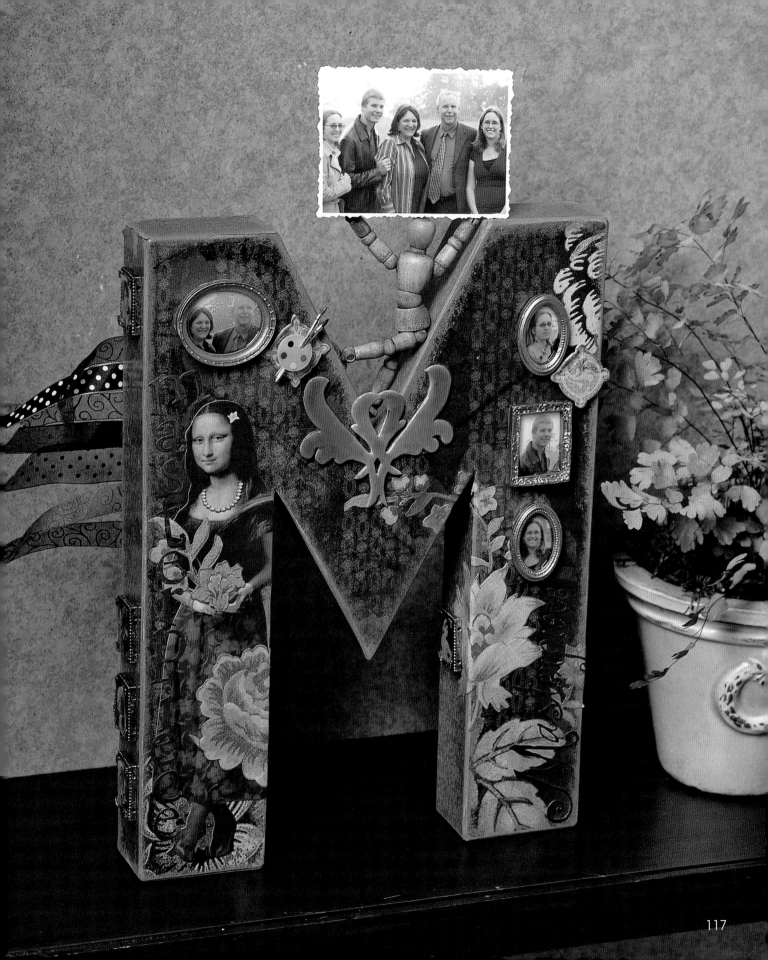

PHOTO
TABLEMATS

Tablemats are a great way to use vintage family photographs to honor the past every day. The original photos were color photocopied and decoupaged with decorative papers and stickers to create these useful "memory pages." I have several sets of these tablemats and use them every day, even under hot dishes right from the oven. You can find these mats at dollar stores or kitchen shops. The two-part polymer coating protects the mats and makes them easy to care for.

Continued on page 120

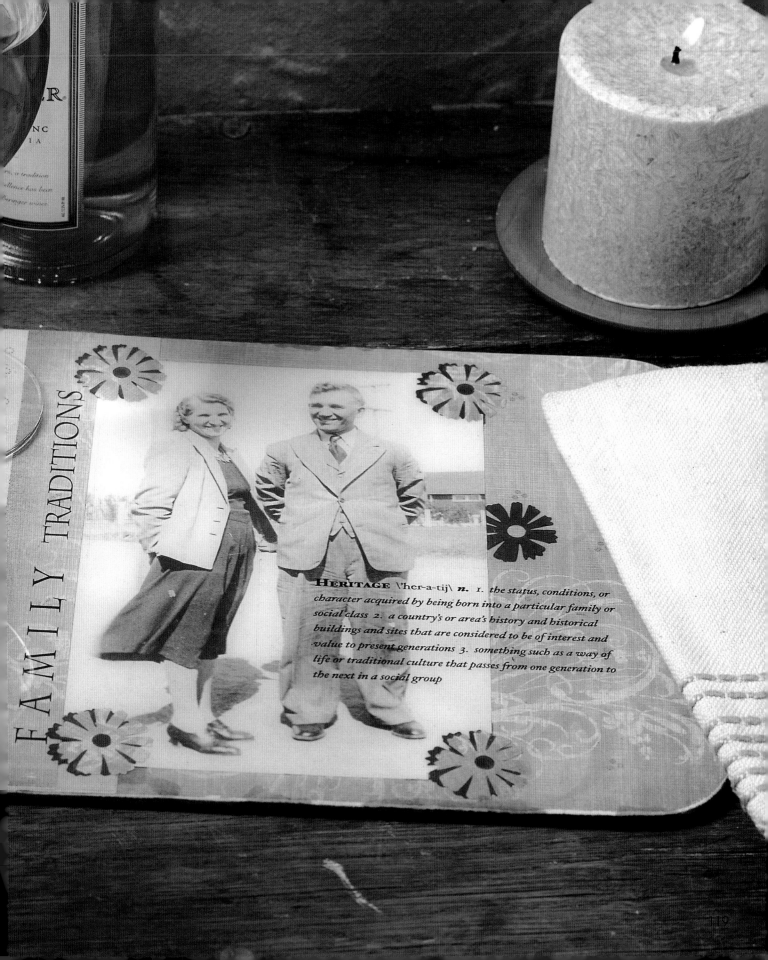

FAMILY TRADITIONS

HERITAGE \'her-a-tij\ *n.* 1. the status, conditions, or character acquired by being born into a particular family or social class 2. a country's or area's history and historical buildings and sites that are considered to be of interest and value to present generations 3. something such as a way of life or traditional culture that passes from one generation to the next in a social group

PHOTO
TABLEMATS

SUPPLIES

Project Surface:

4 cork-backed placemats, 11½" x 8½"

Decorative Elements:

Color-photocopied vintage photos

Coordinating decorative papers

Coordinating decorative stickers *or* rub-ons for accents and journaling

Other Supplies & Tools:

Decoupage medium

Brush

Two-part polymer coating and coating supplies (See the beginning of this chapter.)

Sandpaper, 100 grit

Optional: Gesso

INSTRUCTIONS

1. *Option:* If you are using a light-colored background paper, basecoat the mat with gesso to prevent the print on the mat from showing through. If your paper is thicker or dark colored, skip this step.
2. Cover the entire surface of each mat with decoupage medium and decorative paper cut ½" larger all around than the mat. Let dry.
3. Sand the edges to remove the excess paper.
4. Arrange your photos and embellishments on the surface and decoupage them to the mat. Use the project photo as inspiration.
5. Seal coat each mat twice with thin-bodied white glue.
6. When completely clear and dry, apply the two-part polymer coating. See the instructions at the beginning of this chapter. ❏

CARE CARD

These coasters are heat resistant, waterproof, and alcohol proof. Clean them with a soft damp cloth. Carnauba car polish will prolong the life of the surface and clean away smudges and fingerprints. Objects left on the surface for a period of time may leave impressions. They will disappear in a few hours at normal room temperature.

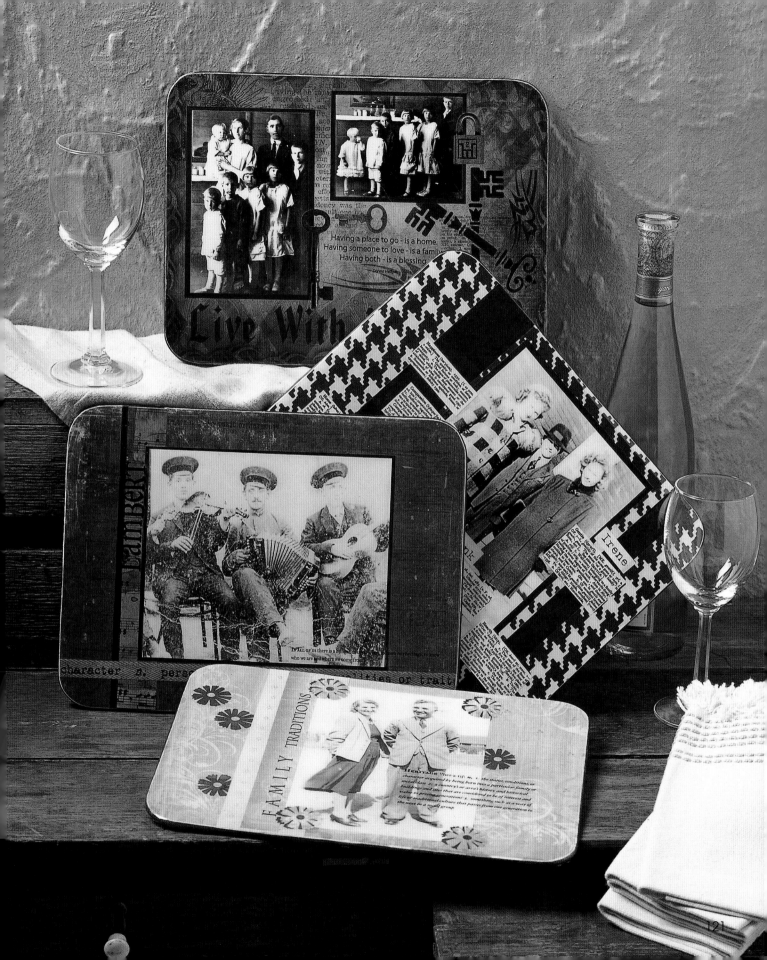

PHOTO
SWITCHPLATES

Photographs can help light up a room with these fun switchplates! This inexpensive project makes an impressive custom accent for any room. The examples include recent photos of my kids climbing and a sepia-toned vintage portrait. Protect the photos and make the switchplates easy to clean by applying several layers of varnish or a polymer coating.

TIP: Creatively crop the photo so the switch and screws do not interfere (unless, of course, you want to replace a nose with a switch!) or obscure an important part of the picture.

SUPPLIES

For one switchplate

White plastic switchplate

Color photocopy of a photo, cropped ½" larger than the plate

Craft knife

Decoupage medium

Brush

Cutting mat

Pencil

Gloss acrylic varnish *or* polymer coating and coating supplies (See the beginning of this chapter.)

INSTRUCTIONS

1. Use decoupage medium to adhere the photocopy of the photo to the switchplate. Cut away the excess paper at the corners and fold the paper over the edges to the back. Let dry completely.

2. Place the covered plate face down on a cutting mat. Use a craft knife to cut an X through the switch opening, corner to corner. Fold the paper pieces to the back and glue to hold.

3. Working from the front side, push a pencil through the screw holes to clear the paper from the holes.

4. Apply several coats of gloss varnish or a two-polymer coating. For coating instructions, see the beginning of this chapter. ❑

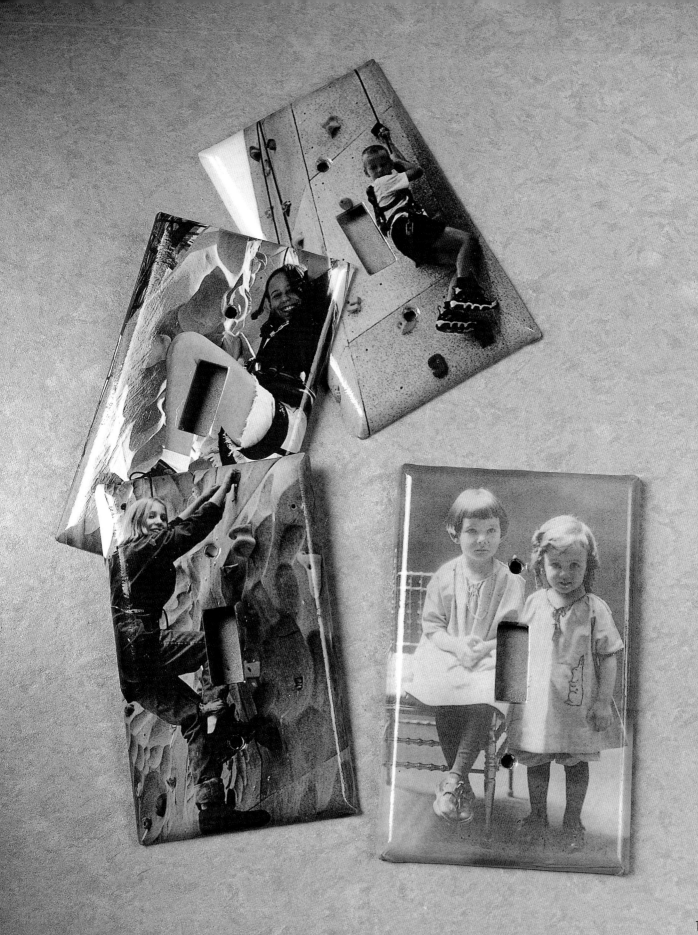

SHADOW BOXES

Shadow boxes are a wonderful way to display photographs along with other treasured souvenirs that do not fit into albums. These sentimental showcases start with an important theme or an important person in your life. They can be hung on a wall or placed on a shelf at eye level or in a bookcase.

Quilting and lacemaking shadow boxes that celebrate my grandmothers are displayed in my sewing room to inspire my projects. A sports theme shadow box could grace a family room, or Grandpa's trade might be honored in the den. Although they are different in appearance, the same basic techniques are used to create them. Use the examples in this chapter as inspiration for creating your own shadow boxes using your cherished photos and memorabilia.

LOUISE'S SHADOW BOX

With this box, Grandmamma Provan is remembered for the beautiful lace she made. I used a brown stain to color the box and selected ephemera images that relate to lacemaking. The background elements are photocopied pages of a journal and a lace pattern done by Grandmamma Provan herself. I added decorative paisley rub-ons, alphabet stickers, buttons, and an oval mat to frame the photograph. Other three-dimensional collage elements that enhance the theme include antique sewing notions (buttons, scissors, a thimble, a wooden spool) and pieces of lace tatted by Louise, which are attached with tacks. ❑

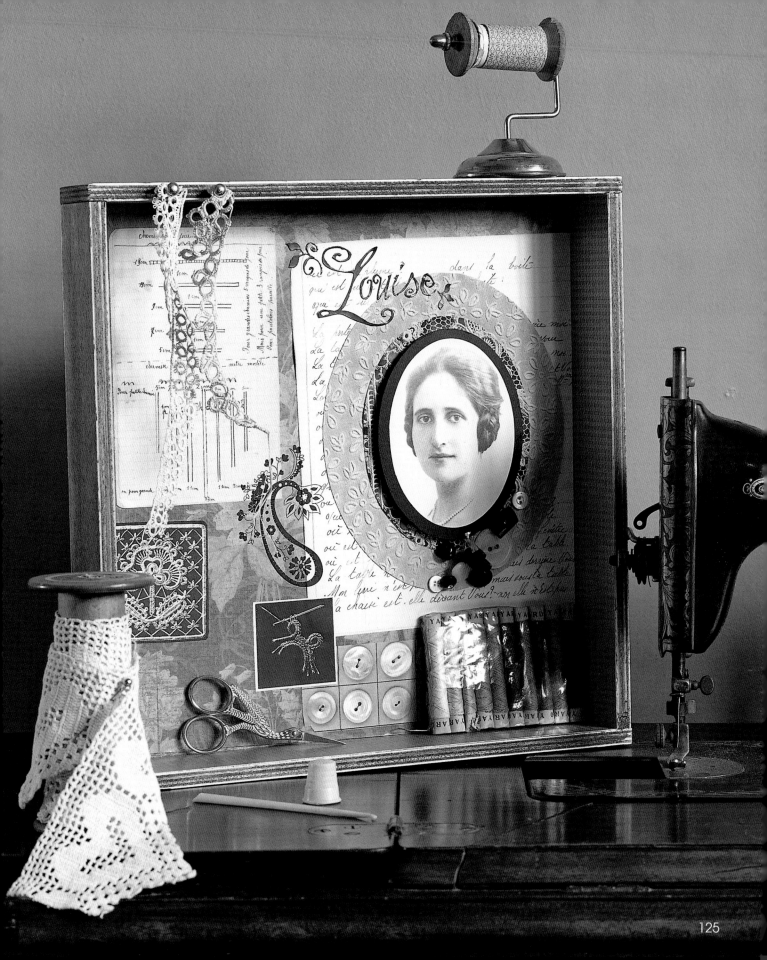

VINTAGE GARDEN
SHADOW BOX

This shadow box has a silk flower arrangement that enhances a center tinted photograph elevated on a smaller shadow box. The tiny toy accents are not glued in place.

SUPPLIES

Project Surfaces:

Wooden shadow box, 12" x 12" x 2"

Wooden shadow box, 6" x 6" x 3½"

Decorative Elements:

Silk flowers – Sepia rose spray, dusty pink peony, light purple hydrangea

Acrylic paint – Deep dusty rose

Decorative paper, one 12" x 12" sheet, in a matching color

1-1/3 yds. cream upholstery braid

Decorative brass tacks

Photo, black and white photocopy, cropped to 6½" square

Acrylic paints and gel medium (for tinting photograph)

Embellishments – Tiny toys

Other Supplies & Tools:

Decoupage medium, satin finish

Sandpaper, 100 grit

Craft glue

Acrylic varnish, satin finish

Glue gun and clear glue sticks

Paint brushes

INSTRUCTIONS

1. Turn the smaller shadow box upside down and glue at the center of the larger shadow box with craft glue. Weight the box with a heavy book while drying for a strong bond.
2. Basecoat all surfaces with deep dusty rose acrylic paint. Let dry.
3. Apply a coat of satin varnish to the painted surfaces. Let dry.
4. Decoupage the photograph to the top of the smaller box.
5. Cut pieces of decorative paper to fit the sides of the smaller box and decoupage in place. Let dry.
6. Sand the edges of the paper flush with the box.
7. Tint the photograph, using the acrylic paint technique. See "Tinting Photos with Acrylic Paint" in Chapter 5.
8. Using white glue, attach the cream braid to the edges of the larger box as shown. Put decorative brass tacks at the corners.
9. Cut apart the silk hydrangea. Using the glue gun, glue the silk flowers around the smaller box, using the photo as a guide for placement.
10. Add the toy embellishments to the arrangement. ❑

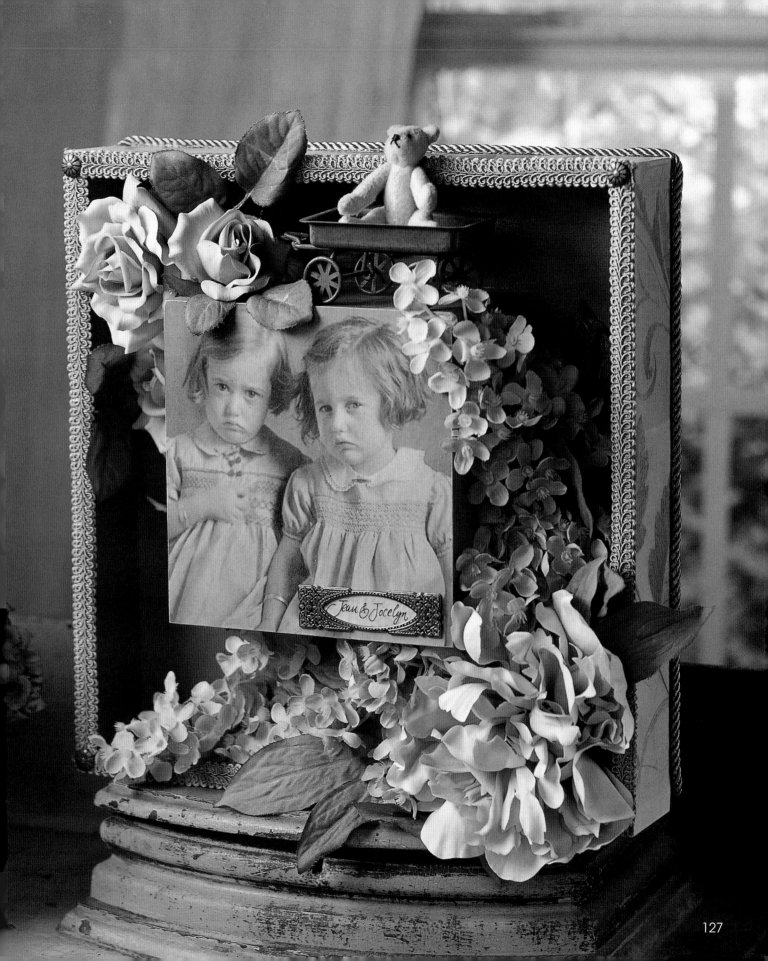

SHADOW
BOX
SHELVES

Photos from Bailey's scuba trip to Hawaii were enlarged and used to create this decorative shelf assembly that can hold small items. The blue and orange colors, inspired by the colors in the photographs, create a bold, contemporary look. Choose paint colors that complement your photos when creating your shadow box shelves.

Instructions begin on page 130

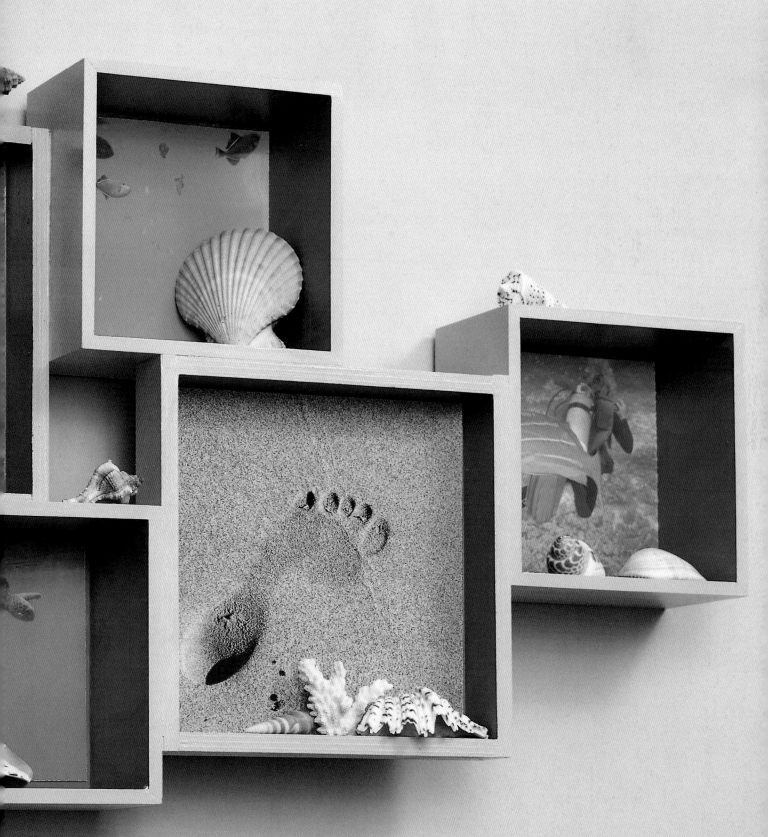

SHADOW BOX
SHELVES

Pictured on page 128 & 129

SUPPLIES

Project Surfaces:

2 wooden shadow boxes, 8" square, 1½" deep

3 wooden shadow boxes, 6" square, 3½" deep

Decorative Elements:

Acrylic paint

Five photos printed on gloss photo paper and
cropped to fit the shadow boxes

Other Supplies & Tools:

Brushes

Craft glue

Wood screws, ⅝" long

Wood filler

Sandpaper, 100 grit

Acrylic varnish, satin finish

Double-sided tape

2 sawtooth hangers

Hammer

INSTRUCTIONS

1. Using the project photo as a guide, attach the boxes together with white craft glue and wood screws. Use wood filler as needed to cover the screw heads. When the filler is dry, sand smooth.
2. Basecoat the shadow boxes, inside and out, with acrylic paints. On these, I painted the inside areas with blue and the edges and outside areas with orange. Apply as many coats as needed for even, solid coverage. Let dry.
3. Finish with a coat of satin varnish. Let dry.
4. Attach a photograph to the back of each shadow box with double-sided tape.
5. Attach the sawtooth hangers to the back of the assembled shelf. ❑

ANNA'S
SHADOW BOX

My Grandma Laturnus was a champion quilter who used all types of reclaimed fabrics for her log cabin quilts. I colored photocopied a piece of one of her quilts for the background along with vintage sewing notion images from an ephemera book.

The shadow box is a plain wooden box, 12" square, from a crafts store. I basecoated it with dark green acrylic paint and distressed the sides with sandpaper. The photocopied images were decoupaged to the inside of the box, and I varnished the entire box, inside and out, with satin finish acrylic varnish.

I mounted the photos on ½" thick foam board with decoupage medium to create dimension and interest. When dry, they were cut to size with a craft knife and ruler. The edges of the foam core pieces were covered with ribbon before the photos were glued into the shadow box with white craft glue.

Embellishments that enhance the theme include sewing pins, vintage button cards, old wooden spools of thread, pieces of fabric, and scissors. ❏

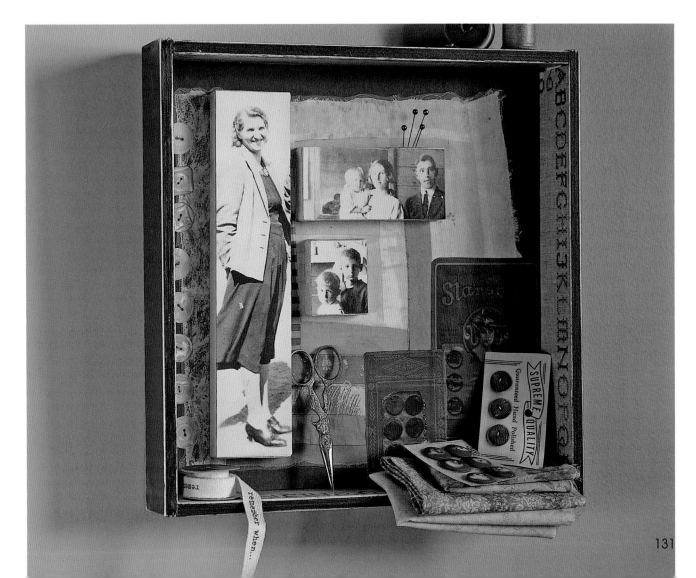

PAINT & PHOTO COLLAGE

Combining paint and photographs is a great way to transform a photo into a work of art. Three types of painted finish techniques are shown at the beginning of this chapter: a layered color wash, a distressed paint finish, and the faded jeans finish.

To protect painted surfaces, apply two or three coats of acrylic varnish when the paint is completely dry.

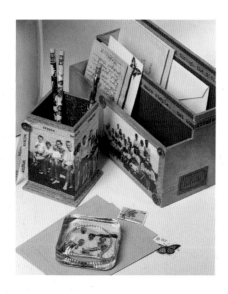

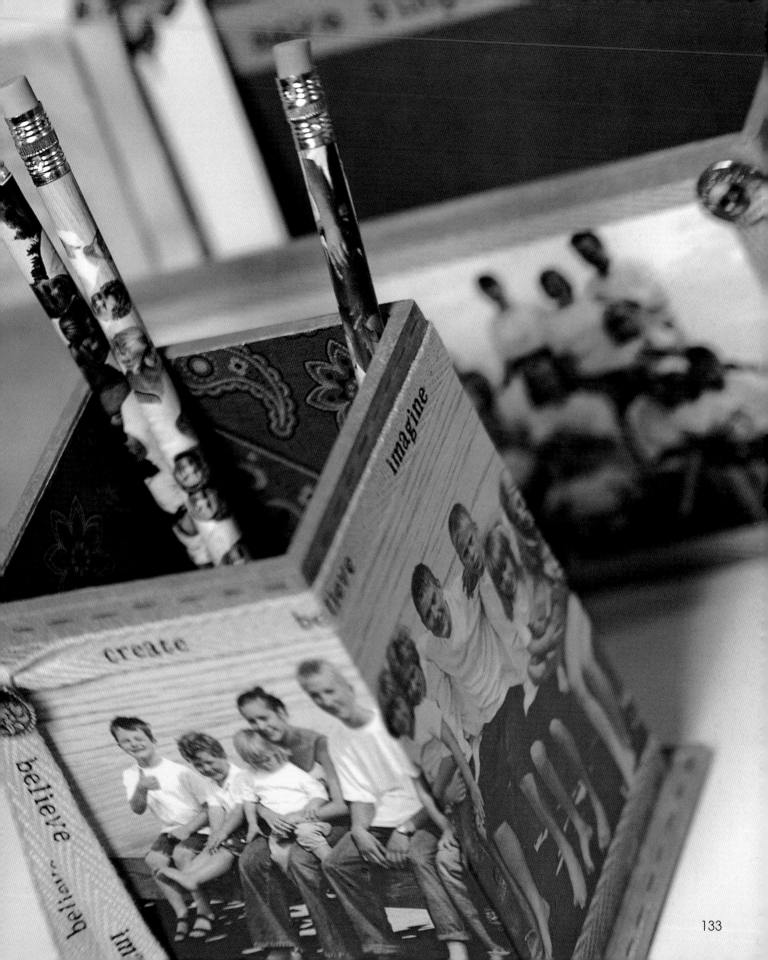

Basecoating Wood

This basecoating technique ensures a smooth, plain painted finish that is a trouble-free base for decorating and finishing. The goal is an evenly covered surface with no patches or brush marks.

Here's How:

1. Prepare for painting by removing any hardware. If your wood surface has knots or dark patches, seal them with an acrylic sealer. Let the sealant dry completely before proceeding.
2. Apply the first coat of acrylic color with a large basecoating brush, evenly coating the surface with paint. Let dry completely before proceeding.
3. Sand the painted area with medium (100 grit) sandpaper to smooth the surface. (Moisture in the acrylic paint tends to raise the wood fibers even if you sand well before painting.) Wipe away the dust.
4. Add another coat of paint. Let dry. If needed, apply a third coat of paint.

Layered Color Wash

In this technique, different colors of acrylic paint are applied in layers to a surface. I use the same paint brush for all the colors and apply them wet-into-wet. This method blends the colors and can create a subtle or dynamic effect, depending on the colors used.

• Choose paint colors to match your photograph.
• Use the same brush to apply all the colors, and don't wash it when you change colors – not washing the brush helps the colors blend.
• Use only three colors if the hues are very different from each other (Example: Blue, brown, tan) You can use more colors if the hues are similar. (Example: Blue, green, teal)
• Obvious brush strokes enhance the effect.
• Relax and have fun!

1. Apply the lightest paint color first.

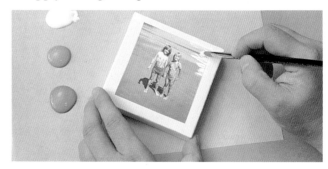

2. Add the Other Colors

Apply the remaining colors, ending with the darkest one. Work fast, overlapping the colors while they are still wet. Do not over mix! You can quickly muddy your colors if you're not careful. If you are unhappy with the results, let the paint completely dry before adding another layer. *Option:* Add some gel medium to the paints to extend the drying time and make the colors more transparent.

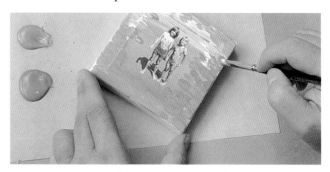

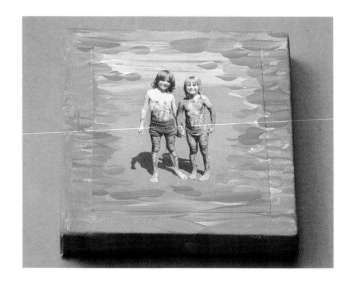

Distressed Paint Finish

This technique instantly creates the look of old painted wood that has developed an interesting patina over time. Wax (an old candle works well) works as a resist and makes sanding off the paint easier. Apply up to three different paint colors for a layered distressed finish.

1. Rub a piece of uncolored wax over the wood surface in areas where normal wear would occur, such as the edges.

2. Apply the paint in a single coat over the entire surface, including the wax. Let dry. If using more than one color, rub on more wax on the first layer of paint, and then add a second paint color. Continue to layer wax and paint. When the final paint color has been applied, let it dry completely.

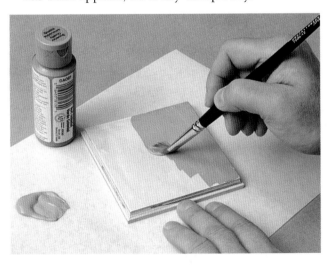

3. Sand the entire piece to reveal the original wood surface plus all the different paint colors.

The finished surface – a natural, weathered look.

Faded Jeans Finish

This faux finish is a nice surface for casual projects.

1. Start by basecoating your surface with denim blue acrylic paint. The lighter the hue, the more "faded" the jeans finish will be.

2. Mix together equal amounts of gel medium and white acrylic paint.

3. Brush an even layer of the paint and gel medium mixture over the surface. I like to work one side of a surface at a time so the glaze doesn't dry before I'm finished.

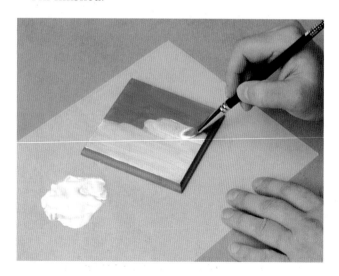

4. Immediately lay a textured cloth (cheesecloth works well) across the surface. Smooth down.

5. Immediately lift off the cloth to reveal the denim effect. Don't worry if there are wrinkles in the finish – it's a nice effect.

6. Tap the Surface (as needed)

 If there are gaps, tap the cloth on the surface as needed. Let dry completely.

7. Use a thin round paint brush with orange acrylic paint to add stitch marks – small (1/8" long) dashed lines – to the edges of the painted surface.

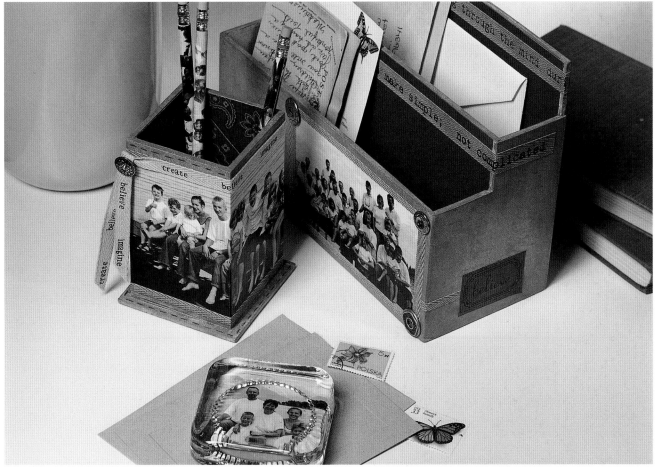

The surface of this desk set was given a faded denim finish. See page 142 for instructions to make the desk set.

JAY'S ADVENTURE
CLIPBOARD

This painted clipboard was decorated and designed to use as a clipboard instead of just a decorative frame. The acrylic colors (dark brown, light tan, and turquoise) were chosen to match the photograph and applied over parts of the transferred image. I printed the photo on decal transfer paper – the transfer allowed the wood grain of the clipboard to show through – but you could also decoupage a color photocopy of the image to the clipboard.

I painted an inspirational saying down one side. TIP: You can create a lettering pattern by printing your saying on the computer in a decorative font of the correct size. Trim the printed lettering. Use white tracing paper (or dark tracing paper if your surface is light-colored) to transfer the lettering pattern to the surface.

SUPPLIES

Clipboard, 9" x 12"

Photo, 8" x 10", printed on decal transfer paper (See Chapter 6, "Photo Transferring.")

Acrylic paints (to match photograph)

Antique white acrylic paint (for journaling)

Paint brushes – ½" filbert, #1 round

Acrylic varnish, gloss finish

Sponge

INSTRUCTIONS

1. Remove the hardware from the clipboard.
2. Brush the clipboard with a coat of varnish. Let dry.
3. Following the manufacturer's instructions, soak the transfer film and slide the transfer on the surface of the clipboard.
4. Gently sponge the transfer to remove any bubbles or wrinkles. Be very careful! At this stage, the decal film can easily tear. Let dry.
5. Apply a coat of gloss varnish to the surface. Let dry.
6. Apply the acrylic paint colors with the filbert brush around the photo to create the background, using the layered color wash technique. See the instructions at the beginning of this chapter. Let dry completely.
7. Use the round brush to paint the inspirational saying with white paint. Let dry.
8. Coat the surface of the clipboard with two to three coats of the varnish to protect it. Let dry.
9. Replace the hardware. ❑

Adventure is worthwhile in itself ~Earhart

SILLY CAMERON
COAT RACK

This fun coat rack uses a subtle layered color wash and whimsical painted frames to accent delightful photographs of Cameron showing off for the camera.

SUPPLIES

Project Base:

Wooden sign board panel, 22" x 6"

3 metal hanger hooks

Decorative Elements:

4 photocopies of 4 black and white photos, cropped to 3" square

Acrylic paints – Light blues and greens, dark purple, white

Other Supplies & Tools:

Low-tack masking tape

Ruler

Paint brushes – Basecoat brush, #1 round

Decoupage medium

INSTRUCTIONS

1. Basecoat the board with medium blue paint.
2. With the other paint colors, detail the edges of the board.
3. Mark the center of the board. Working from the center, mask off four 4" squares equally spaced with masking tape.

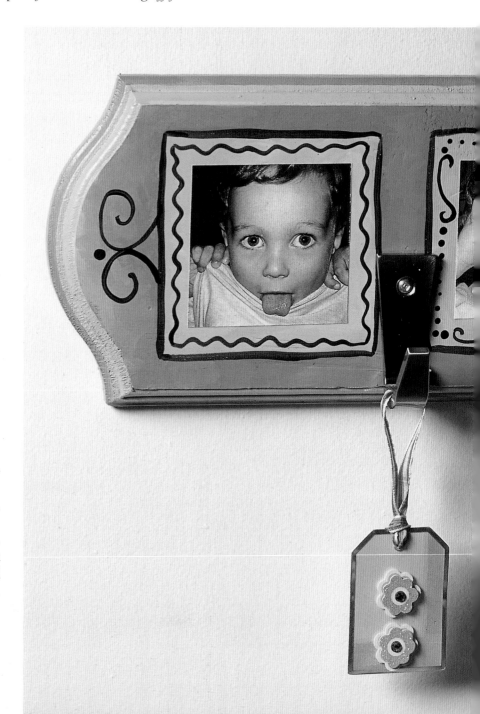

4. Paint the inside of each masked-off square panel with a color and white, using the layered color wash technique. See the beginning of this chapter for instructions. (This adds a subtle painted finish to each panel.) Remove the tape. Let dry completely.

5. Using decoupage medium, adhere a photo in the center of each square panel. Coat with a protective layer of decoupage medium. Let dry.

6. Using the round brush with dark purple paint, outline each square painted panel and add decorative elements to the frame. Use the project photo for design ideas. Doing this freehand creates a whimsical effect. Let dry.

7. Apply two coats of varnish. Let dry.

8. Attach the hooks at the bottom edge. ❏

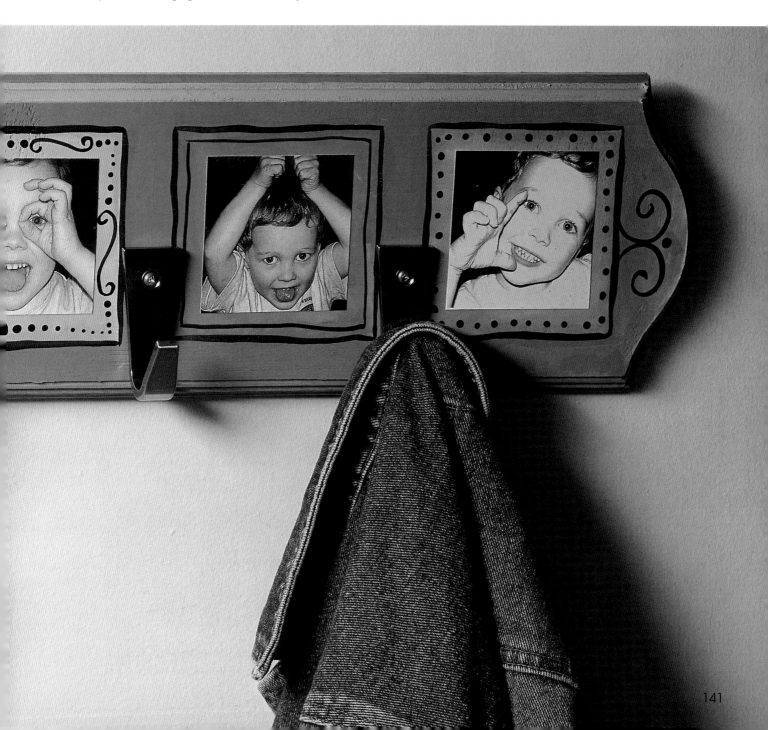

OUR FAMILY
DESK COLLECTION

Family photographs decorate this desk trio. The faded denim paint finish and rust decorative paper gives the collection a casual look – they would look great on Dad's desk. I covered wooden pencils with a matching photograph that I cut into 1" strips.

SUPPLIES

Project Surfaces:

Fiberboard file holder, 10" x 4" x 7"

Fiberboard pencil cup, 3" x 3" x 5"

Wooden pencils

Photo glass paperweight, 3" x 3" x ¾"

Mat board, 3" square

Decorative Elements:

Photos, color photocopied and cropped to fit

Acrylic paints – Denim blue, white, orange

Decorative paper – rust bandanna print

Rust card stock

Stickers – leather patches

Printed twill tape

Printed twill ribbon

Silver buttons

Other Supplies & Tools:

Gel medium

Cheesecloth

Artist's brush – #1 round

Decoupage medium

Craft glue

Acrylic varnish, satin finish

INSTRUCTIONS

1. Apply a faded denim paint finish to the outside of the file holder and pencil cup, following the instructions found at the beginning of this chapter.
2. Cut two rust card stock panels to fit the folder slots.
3. Cut four rust bandanna paper panels to fit inside the pencil cup.
4. Using the project photo as a guide, decoupage the photos in place on the file holder, pencil cup, mat board, and wooden pencils.
5. Brush all the painted and decoupaged surfaces with a coat of satin varnish. Let dry.
6. Add the stickers to frame and accent the pieces, using the project photo for placement ideas.
7. Apply a second coat of varnish to all the pieces.
8. Glue the buttons and twill ribbon as shown.
9. Use white glue to adhere the glass paperweight to the decoupaged mat board piece. ❏

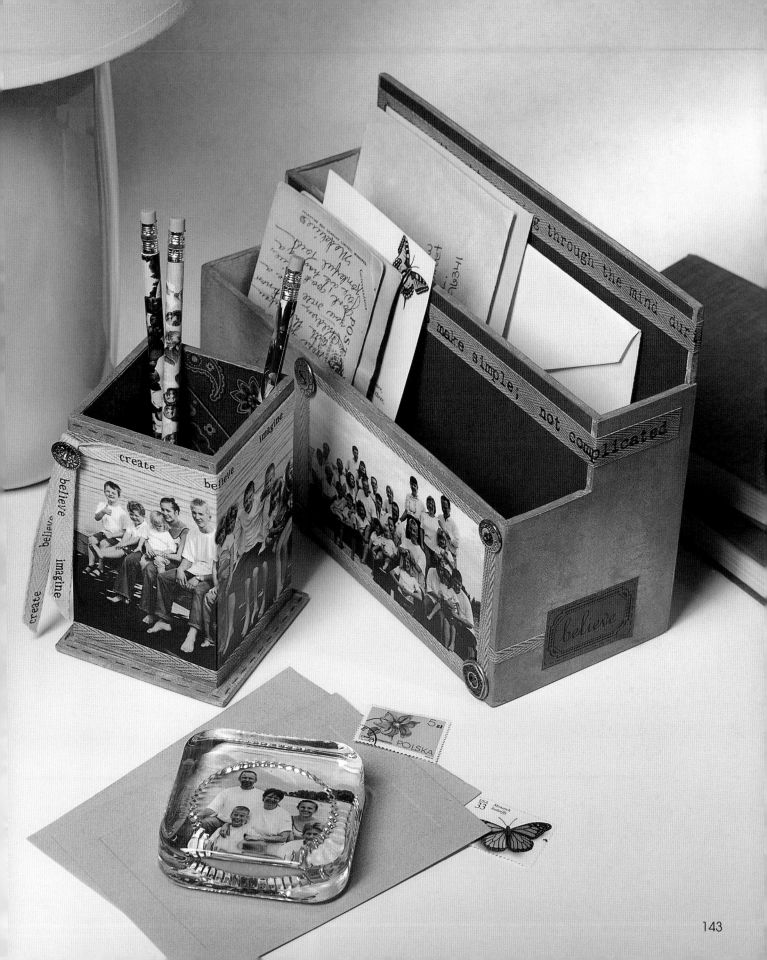

LAMINATING

Laminating photographs with clear-adhesive backed sheets is another way to preserve them and create functional photocraft projects. If you are planning to create lots of paper or photo projects, a laminating machine is a wise investment. The machine can apply a single-sided laminated surface, a double-sided laminate, or a laminate with a magnetic sheet. The system also can be used to apply all-over adhesive to the backs of paper pieces for an easy and quick adhesion (like having custom stickers).

However, you don't need a machine to create laminated photocrafts. Single- and double-sided adhesive laminating sheets are available for purchase individually, as are adhesive magnetic sheets. I also like to use decoupage medium to laminate paper pieces between mica sheets for a unique, vintage look.

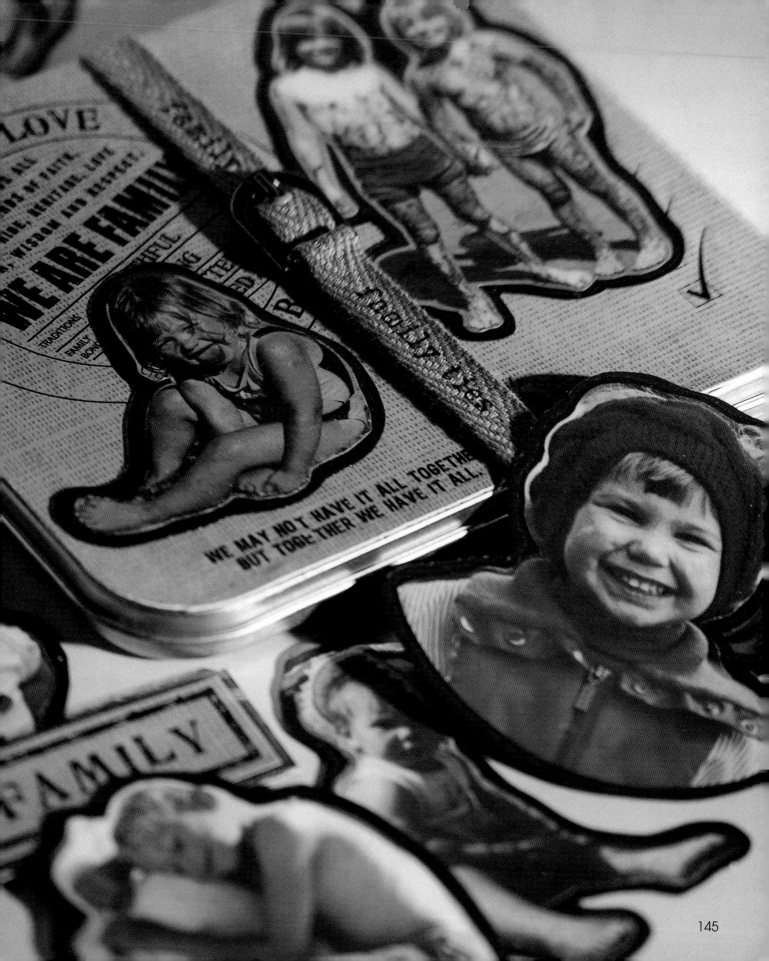

LAMINATING MATERIALS

Any see-thru material can be used to laminate. Typically plastic film is used. Another interesting material to use for laminating is mica. Mica is a natural mineral material that is perfect for laminating photographs. It has a clear topaz brown coloring and a natural shimmer that gives photos an antique look. Mica pieces also can be stamped with permanent inks.

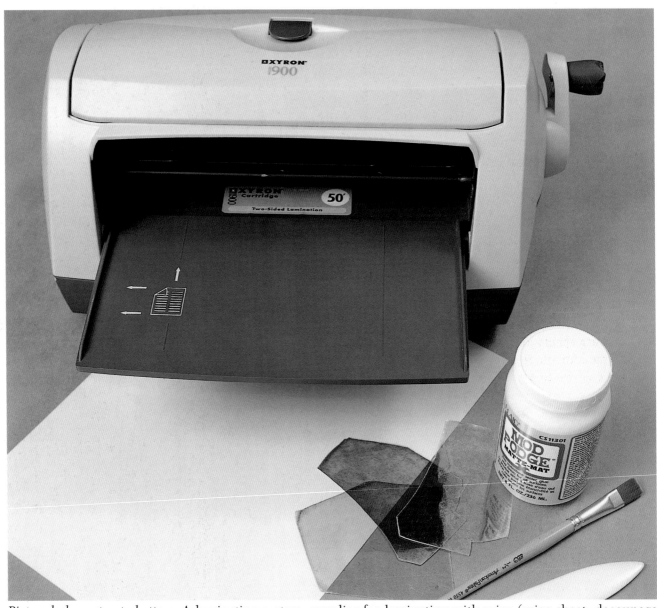

Pictured above, top to bottom: A laminating system, supplies for laminating with mica (mica sheet, decoupage medium, brush, bone folder)

Laminating with Mica

Determine the photo or photos you would like to laminate between the sheets of mica. You will need two photographs of the same size. Trim away margins if there are any. Glue these two photographs together, back to back with a glue stick.

1. Separate the Layers

Mica comes in sheets that can be separated into four to eight thin layers that become thinner and lighter in color as the layers are taken apart. You will need two layers of the same size, large enough to cover photo.

2. Apply Decoupage Medium

Use decoupage medium to adhere the photos to the mica sheets for laminating. Brush a thin layer of the medium on each photo and place the mica sheet over it. Allow to dry.

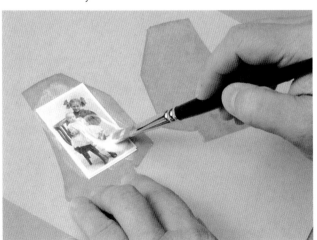

3. Mark

Mark mica with a permanent marker for cutting. Pictured here, a tag-shaped template is being used to mark the mica for cutting.

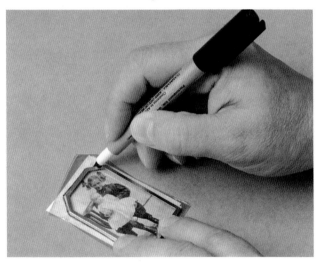

4. Cut

Cut the transparent sheets to size with scissors. Trim along the inside of the marked lines.

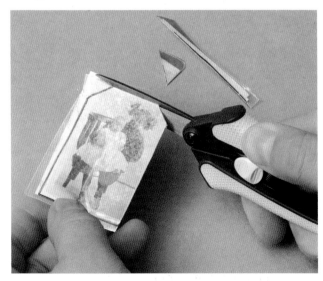

MICA CHARM NECKLACE

I like to use mica laminating to make memory jewelry. Mica pieces are used to create the photo tag dangles, which are threaded with vintage beads, charms, and findings to create this unique piece. The finished length is 16".

SUPPLIES

Decorative Elements:

3 vintage photos, reduced, color photocopied, and cropped – one 1" x 1", one ½" x 1½", one 1" x 1¼"

Decorative paper, vintage script design

Mica, separated into thin sheets

Assorted vintage beads – Gemstones, faceted glass, silver filigree, silver spaces – a variety of shapes and sizes

Assorted silver charms

Gold spacer beads

Silver clasp

Eye pins

Other Supplies & Tools:

Mini eyelets

Eyelet setting tools

Beading wire, 24" length

Crimp beads

Beading tools – Crimper, wire cutters, roundnose pliers

Glue stick

Decoupage medium

Brush

Mouse pad *or* other soft surface

Push pin

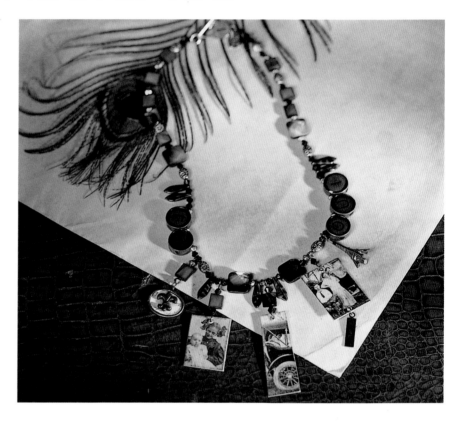

INSTRUCTIONS

1. Using a glue stick, adhere the decorative paper to the backs of the photo pieces.
2. Laminate both sides of the paper pieces with mica sheets and decoupage medium. See the beginning of this chapter for instructions. Let dry and trim to size.
3. On a soft surface such as a mouse pad, pierce a hole in the laminated pieces where you wish to place the eyelets. (Use the project photo as a guide.)
4. Set the eyelets in the pieces. (They help reinforce the holes.)
5. Open the loop on an eye pin and thread the wire through the top of one laminated tag. Close the loop. Add beads to the pin to make the dangle and make a loop at the top. Repeat the process to make more dangles, one for each photo tag, more if you like.
6. Thread one side of the clasp on one end of the beading wire. Add the crimp bead and crimp. Using the photo as a guide, thread the beads, charms, and beaded tag dangles along with the beads and charms on the beading wire to make a necklace 16" long.
7. Add the other side of the clasp and a crimp bead to the wire. Pull taut. Crimp bead and trim the wire end. ❑

MICA CHARM BRACELET

This lightweight bracelet uses a vintage sepia-toned photocopy of a family photo to make a beautiful statement, but hand-tinted photocopies and color copies would also be beautiful. The width of the laminated photo pieces depends in part on the spacing of the people in the photograph; crop the photo pieces no more than 1" wide for best results. The finished length of this bracelet is 7".

SUPPLIES

Vintage photo, color photocopied and cropped to make 5 five pieces, each 2" long and ½" to ¾" wide

Decorative paper, vintage script design

Mica, separated into thin sheets

Seed beads, colors to match

Silver spacer beads

Silver clasp

Other Supplies & Tools:

Glue stick

Decoupage medium

Brush

Jewelry glue

Beading wire, two 10" lengths

Crimp beads

Beading tools – Crimper, wire cutters

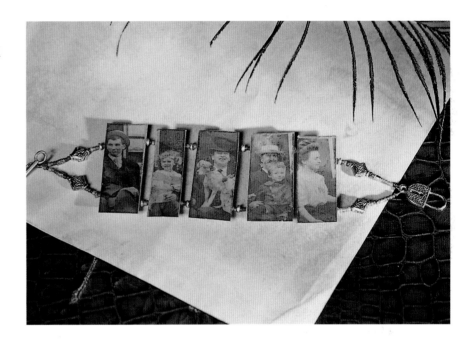

INSTRUCTIONS

1. Using a glue stick, adhere the decorative paper to the backs of the photo pieces.
2. Laminate both sides of the paper pieces with mica sheets and decoupage medium. Let dry and trim to size.
3. With jewelry glue, adhere two silver spacer beads to the back of each laminated piece, spacing them evenly ½" from the top and bottom. **Do not** get any glue in the holes of the spacer beads. Let dry completely.
4. Thread one side of the clasp on the ends of the wire pieces. Add a crimp bead and crimp to secure. Thread on a few beads, then separate the wires and add more beads, using the photo as a guide.
5. Thread the beading wire through spacer beads on the backs of the laminated photos, separating the pieces with a few seed beads as shown.
6. When you've added all the photo pieces, add more beads to each wire as shown to make a bracelet of the desired length. Bring the wires together and add the other side of the clasp and a crimp bead to the wire. Pull taut. Crimp bead and trim the wire end. ❑

POSTCARDS
FROM MY PHOTOS

Postcards are a welcome greeting for family and friends, and a nice way to share your photos. Laminating makes photos sturdier. A standard-size postcard is 3½" to 4¼" x 5" to 6" – anything larger is considered oversized and cannot be sent at the postcard rate. A 4" x 6" photograph fits nicely within the postcard size requirements. I designed a postcard back with spaces for the message and address on my computer, using a turn-of-the-century postcard design as my inspiration.

I like to use a needle-point permanent black marker for writing on photo postcards as the marker does not dent the front of the postcard and the ink will not run in humid weather.

SUPPLIES

For one postcard

Photo, 4" x 6"

Postcard back printed on white paper

Rub-on salutation

Bone folder

Paper trimmer

Computer and printer

Laminating system with a laminating/adhesive cartridge *or* laminating sheet and glue stick

Needle-point permanent black pen

INSTRUCTIONS

1. Add a rub-on salutation to the front of the photograph, using the bone folder.
2. Send the photo, face up, through a laminating system containing a laminating/adhesive cartridge. (This laminates the top of the photo and applies an adhesive to the back for adhering the postcard back.) Adhere the postcard back.

If you do not have a laminating system, simply cover the photograph with a laminating sheet, rub with a bone folder for a good bond, and glue the postcard back to the back of the photo with a glue stick. ❏

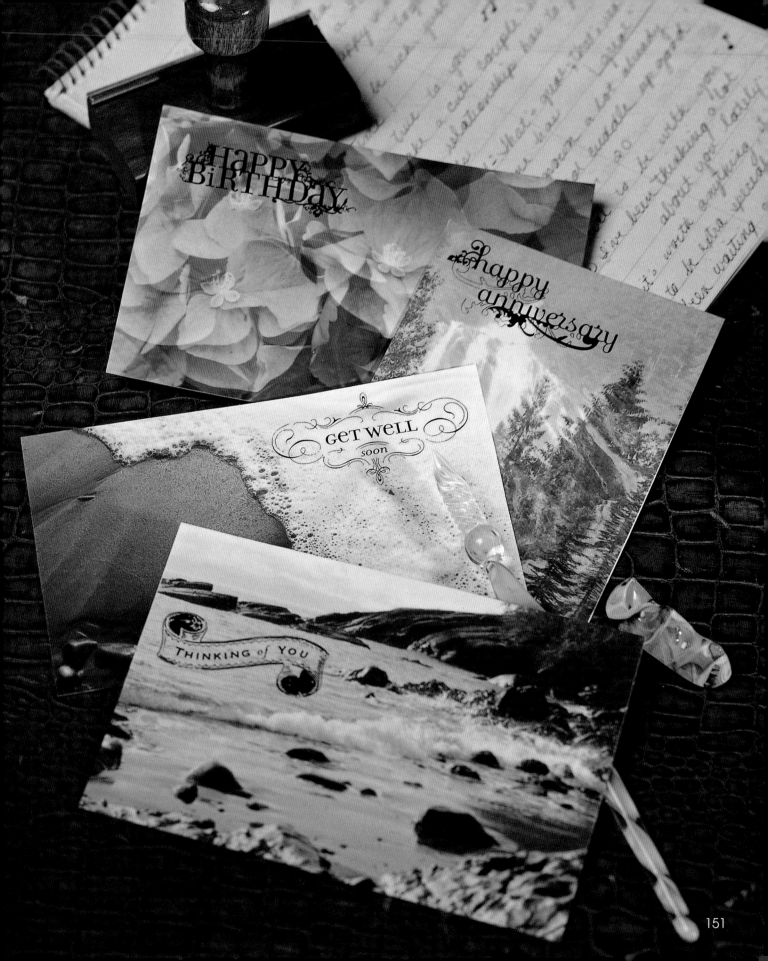

SPECIAL DISHES
RECIPE CARDS

Recipe cards adorned with photos are an easy, personalized gift to slip into a greeting card. Laminating the cards protects them from kitchen spatters for years of use. The recipe cards are a also a great addition to a gift of homemade goodies, a bridal shower gift, or a hostess gift. Choose a photograph that illustrates or enhances the recipe.

SUPPLIES

Photo, cropped to 3" square

Card stock, in a color that complements the photo

Laminating film *or* laminating system with double-sided lamination cartridge

Glue stick

Computer and printer

White paper

INSTRUCTIONS

1. Cut the card stock to 6" x 3¾".
2. Using your computer, print the recipe and title. Use a text box to make sure your recipe fits in a 3" square. For long recipes, make a second panel that can be glued on the back of the card. *Option:* Print sayings or stories for gluing to the back of the recipe card.
3. Using the glue stick, glue the photo, recipe, and title to the card stock.
4. Laminate both sides of the card.
5. Trim off ½" from half of the top of the card to form the tab for the title. ❏

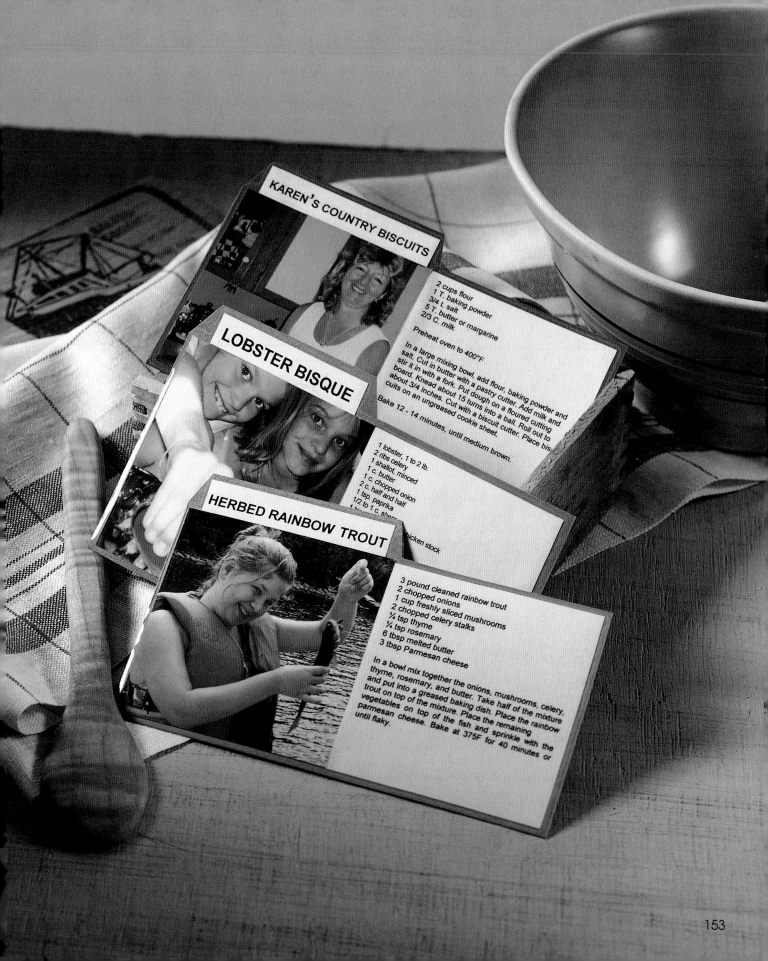

KAREN'S COUNTRY BISCUITS

2 cups flour
1 T. baking powder
3/4 t. salt
5 T. butter or margarine
2/3 C. milk

Preheat oven to 400°F

In a large mixing bowl, add flour, baking powder and salt. Cut in butter with a pastry cutter. Add milk and stir it in with a fork. Put dough on a floured cutting board. Knead about 15 turns into a ball. Roll out to about 3/4 inches. Cut with a biscuit cutter. Place bis- cuits on an ungreased cookie sheet.

Bake 12 - 14 minutes, until medium brown.

LOBSTER BISQUE

1 lobster, 1 to 2 lb.
2 ribs celery
1 shallot, minced
1 c. chopped onion
1 c. butter
2 c. half and half
1 tsp. paprika
1/2 to 1 c. sher
1/2 t
chicken stock

HERBED RAINBOW TROUT

3 pound cleaned rainbow trout
2 chopped onions
1 cup freshly sliced mushrooms
2 chopped celery stalks
¼ tsp thyme
¼ tsp rosemary
6 tbsp melted butter
3 tbsp Parmesan cheese

In a bowl mix together the onions, mushrooms, celery, thyme, rosemary, and butter. Take half of the mixture and put into a greased baking dish. Place the rainbow trout on top of the mixture. Place the remaining vegetables on top of the fish and sprinkle with the parmesan cheese. Bake at 375F for 40 minutes or until flaky.

SCRAPBOOK PAGE
PLACEMAT

You can quickly create a fun mat by simply laminating a scrapbook page! Use a favorite photograph along with alphabet letters, stickers, and decorative paper to create a personalized mat for a season or a special event. This placemat is 9" x 12" and was laminated both sides with a laminating system. For larger placemats, you can use the clear sticky paper that comes on rolls and is available at hardware stores.

While this placemat won't last forever, it can be used for several months – just wipe with a damp cloth to keep it clean. You could also have children help make their own seasonal mats as a fun, rainy day project.

REFRIGERATOR MAGNET
GIFT SET

*This set of laminated photographs with magnetic backs is a fun way to create
your own photo gallery for the refrigerator or a filing cabinet. It's also a brilliant
gift idea for a family. I like to make quote magnets to pair with the photographs.*

To make: Choose favorite photographs and cut out the images, leaving a slight edge. Laminate the images in a laminating machine with a laminate/magnet cartridge *or* sandwich the photos between single laminating and magnet sheets. Cut out the images, leaving a 1/8" black border (the magnetic sheet) as a frame.

For a gift set, decorate the top of a CD tin with decorative paper, rub-ons, and some of the photo magnets. Place the rest of the magnets inside the tin and wrap with a piece of printed ribbon and a ribbon buckle. ❑

MICA TAGS

I used the mica laminating technique to make these framed photo tags.
The tags can adorn a package or a scrapbook page, or they could be
used in a collage or altered art piece. I backed these with script-patterned
paper, but you could use paper with your own journaling instead.
One tag is 1¾" x 2¾"; the other is 1½" x 2¼".

SUPPLIES

For one tag

Decorative Elements:

Silver tag frame

Vintage photo, reduced, color-photocopied, and
 cropped to fit

Rub-on salutation

Decorative paper with vintage script design

Mica, separated into thin sheets

Silver beads and charms

Dark brown linen cord

Optional: Head pins or eye pins

Other Supplies & Tools:

Glue stick

Decoupage medium

Brush

Mini eyelets

Eyelet setting tools

Mouse pad *or* other soft surface

Push pin

INSTRUCTIONS

To make a tag, follow these basic instructions. Use the
examples in the project photo as guides for bead selec-
tion, decoration, and hanger ideas.

1. Decorate the photograph with a rub-on salutation.
2. Using a glue stick, adhere the decorative paper to
 the back of the photograph.
3. Laminate both sides of the paper pieces with mica
 sheets and decoupage medium. Let dry. Trim to fit
 the frame.
4. On a soft surface such as a mouse pad, pierce a
 hole in the laminated piece where you wish to add
 eyelets for hanging or to add charms or beaded
 dangles for decoration. Set the eyelet(s) in the
 piece. (This helps to reinforce the hole(s).)
5. Loop linen cord through the eyelet to make the
 hanger. Add beads and knot to secure. *Option:* Add
 beaded dangles on eye pins or head pins or charms
 through a second eyelet. ❏

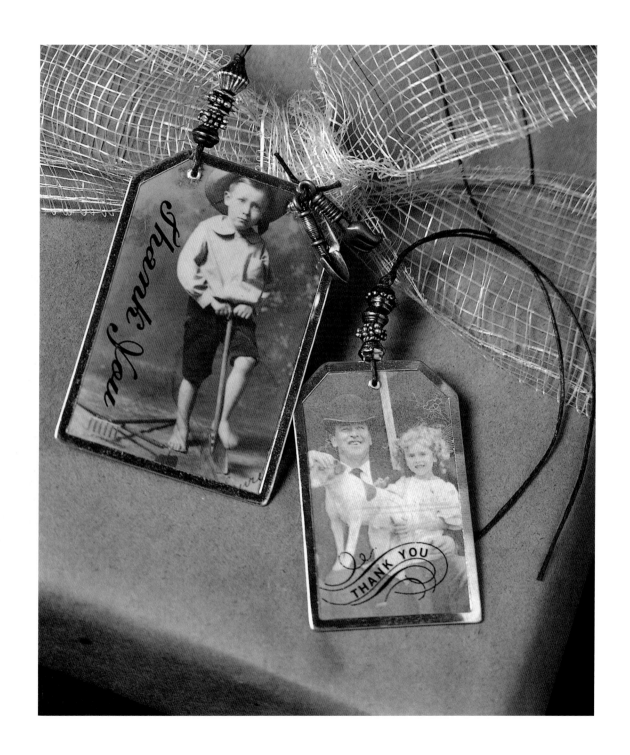

PET GOODIE TIN

Tins make useful, usable gift containers. This one is filled with doggy treats and covered with decorative panels that were laminated.

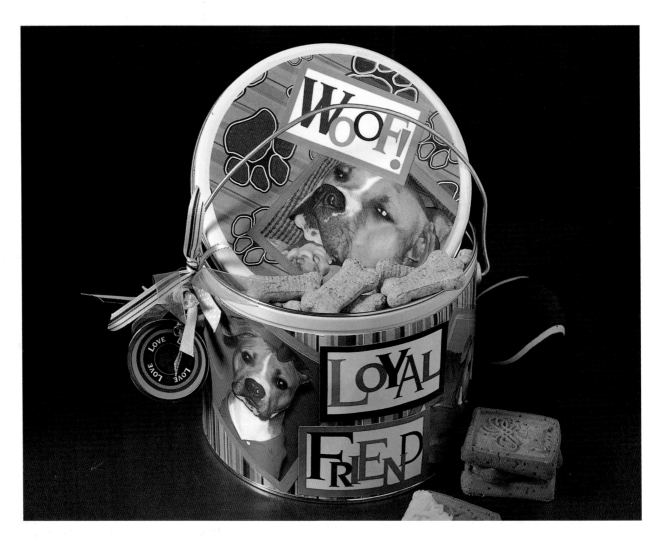

To make: Remove the handle from the tin and carefully measure the top and sides. Create the panels with lightweight decorative papers, color-photocopied photographs, and stickers. Put the panels through a laminating machine with a laminate/adhesive cartridge, trim them, and place them on the tin. To finish, replace the handle and decorate with a tag and matching pieces of ribbon. ❏

METRIC CONVERSION CHART

Inches to Millimeters and Centimeters

Inches	MM	CM	Inches	MM	CM
1/8	3	.3	2	51	5.1
1/4	6	.6	3	76	7.6
3/8	10	1.0	4	102	10.2
1/2	13	1.3	5	127	12.7
5/8	16	1.6	6	152	15.2
3/4	19	1.9	7	178	17.8
7/8	22	2.2	8	203	20.3
1	25	2.5	9	229	22.9
1-1/4	32	3.2	10	254	25.4
1-1/2	38	3.8	11	279	27.9
1-3/4	44	4.4	12	305	30.5

Yards to Meters

Yards	Meters	Yards	Meters
1/8	.11	3	2.74
1/4	.23	4	3.66
3/8	.34	5	4.57
1/2	.46	6	5.49
5/8	.57	7	6.40
3/4	.69	8	7.32
7/8	.80	9	8.23
1	.91	10	9.14
2	1.83		

INDEX

INDEX